WHAT ARE MUSEUMS FOR?

The status quo is broken. Humanity today faces multiple interconnected challenges, some of which could prove existential. If we believe the world could be different, if we want it to be *better*, examining the purpose of what we do – and what is done in our name – is more pressing than ever.

The What Is It For? series examines the purpose of the most important aspects of our contemporary world, from religion and free speech to animal rights and the Olympics. It illuminates what these things are by looking closely at what they do.

The series offers fresh thinking on current debates that gets beyond the overheated polemics and easy polarizations. Across the series, leading experts explore new ways forward, enabling readers to engage with the possibility of real change.

Series editor: George Miller

Visit **bristoluniversitypress.co.uk/what-is-it-for** to find out more about the series.

Available now

WHAT ARE ANIMAL RIGHTS FOR?
Steve Cooke

WHAT IS CYBERSECURITY FOR?
Tim Stevens

WHAT IS HISTORY FOR?
Robert Gildea

WHAT ARE MUSEUMS FOR?
Jon Sleigh

WHAT ARE THE OLYMPICS FOR?
Jules Boykoff

WHAT IS PHILANTHROPY FOR?
Rhodri Davies

WHAT ARE PRISONS FOR?
Hindpal Singh Bhui

WHAT IS WAR FOR?
Jack McDonald

Forthcoming

WHAT IS ANTHROPOLOGY FOR?
Kriti Kapila

WHAT IS COUNTERTERRORISM FOR?
Leonie Jackson

WHAT IS DRUG POLICY FOR?
Julia Buxton

WHAT IS FREE SPEECH FOR?
Gavan Titley

WHAT IS HUMANISM FOR?
Richard Norman

WHAT IS IMMIGRATION POLICY FOR?
Madeleine Sumption

WHAT IS JOURNALISM FOR?
Jon Allsop

WHAT IS THE MONARCHY FOR?
Laura Clancy

WHAT IS MUSIC FOR?
Fleur Brouwer

WHAT ARE NUCLEAR WEAPONS FOR?
Patricia Shamai

WHAT IS RELIGION FOR?
Malise Ruthven

WHAT ARE STATUES FOR?
Milly Williamson

WHAT IS VEGANISM FOR?
Catherine Oliver

WHAT ARE ZOOS FOR?
Heather Browning and Walter Veit

JON SLEIGH (he/him) is a freelance Learning Curator, educator and art history writer. He works nationally as a specialist in museum and fine art engagement with a diverse portfolio of arts institutions, museums and heritage sites across the UK. Clients include the National Gallery, the Courtauld, Tate, the National Archives, Historic Royal Palaces, the Museum of London and the Government Art Collection DCMS. Prior to this Jon worked for Birmingham Museums Trust in round one of the acclaimed ACE National Partners Programme. He produces, delivers and consults on museum and art engagement. Jon has built a national reputation for innovation, applied ethics and delivery of projects reflecting inclusive futures. He has a passion for challenging and under-represented narratives in collections – co-producing with communities to bring their lived experience to pieces for advocacy.

WHAT ARE
MUSEUMS
FOR?

JON SLEIGH

First published in Great Britain in 2024 by

Bristol University Press
University of Bristol
1–9 Old Park Hill
Bristol
BS2 8BB
UK
t: +44 (0)117 374 6645
e: bup-info@bristol.ac.uk

Details of international sales and distribution partners are available at
bristoluniversitypress.co.uk

British Library Cataloguing in Publication Data
A catalogue record for this book is available from the British Library

ISBN 978-1-5292-3139-7 paperback
ISBN 978-1-5292-3140-3 ePub
ISBN 978-1-5292-3141-0 ePdf

Cover design: Tom Appshaw
Bristol University Press uses environmentally
responsible print partners.
Printed and bound in Great Britain by CPI Group (UK) Ltd,
Croydon, CR0 4YY

FSC
www.fsc.org
MIX
Paper | Supporting
responsible forestry
FSC® C013604

To Jozie, owner of a huge heart,
and a gift to all museums

CONTENTS

List of Figures **xii**

Acknowledgements **xiv**

1 **Introduction: The Emotional Museum Encounter** **1**

2 **The Classical Museum** **13**

3 **The Museum in Service of Others** **31**

4 **The Digital Museum** **47**

5 **The Museum and Trust** **68**

6 **The Queer Museum** **82**

7 **The Changing Museum** **101**

8 **The Future Museum?** **121**

Notes **140**

Further Reading **142**

Index **147**

LIST OF FIGURES

1.1 *Ashmolean Mummy Boy 3* by Angela Palmer. 5
From the exhibition 'Angela Palmer:
Unravelled, The Journey of an Egyptian Child
Mummy and Other Portraits 21 May–12 June
2008', Ashmolean Museum, Oxford
(photo: Richard Holttum, reproduced
by permission of the artist)

2.1 Marble portrait head of Alexander the Great 15
(300 BCE–150 BCE). British Museum
© The Trustees of the British Museum
(reproduced with permission)

3.1 Ford Madox Brown, *The Last of England*, 31
1852–55. Birmingham Museum & Art Gallery
(reproduced under Creative Commons
CC0 licence)

4.1 Boiserie from the Hôtel de Varengeville, Paris, 47
c. 1736–52, with later additions. Metropolitan
Museum of Art, New York (reproduced under
The Met's Open Access policy)

5.1 Television set from Bombay Street, Belfast, 70
1969. National Museums NI (photo: Jon Sleigh)

5.2 Television set (detail). National Museums NI 81
(photo: Jon Sleigh)

6.1 Matt Smith, *Happy Union*, 2010, ceramic 82
sculpture (purchased by the Walker Art Gallery

with Art Fund support in 2017) (photo: Liverpool Museums)

7.1 Pitt Rivers Museum signage (photo: Pitt Rivers 102
Museum, University of Oxford, reproduced
with permission)

8.1 Exile installation at Kingston Lacy. National 129
Trust/RCMG/University of Leicester (photo:
National Trust images/Steven Haywood,
reproduced with permission)

8.2 Museum of Homelessness, August 2020 133
(photo: Daniela Sbrisny)

ACKNOWLEDGEMENTS

First, heartfelt thanks to all the contributing voices of the book – each of you continues to inspire me. Similarly, to all the venues I've visited and collaborated with here in profile, my huge thanks for your kindness, access and the stream of tea provided. To the peers who have supported me in companionship, reflection, hugs and inspiration while making this book, your hearts, minds and time are so very valued by me. To my editor, George, for his tireless help, encouragement, support and humour, my deep thanks and appreciation. My final thanks are to the countless museum visitors who chatted to me and shared emotion on the pieces – I hope I honoured your sharing here, and your kindness.

1

INTRODUCTION: THE EMOTIONAL MUSEUM ENCOUNTER

Picture a museum – what do you see? Perhaps a towering institution with Greek columns run by hundreds of staff? A blockbuster exhibition? Mummies, bones and knightly weapons behind glass? Culture with a capital C – serious and important, entwined with a city's or nation's identity? The image portrayed on TV and in movies? Or perhaps a small building filled with 'stuff' and lovingly run by one enthusiast. The fact that you *can* imagine a museum demonstrates their power in our lives. I wonder, though, if you have ever felt a bit out of place in a museum? Yes? Me too, and I work in them.

In asking what museums are for, it's important to establish why I am asking this and also, in turn, to establish my voice as an author. Who we are and how we are perceived matters in museum and gallery spaces.

As a Learning Curator devising exhibitions, working with people to share their stories, and programming participation around this principle, I have the privilege of working in museums and galleries across the UK. You'll often find me smartly dressed in a bow tie, shirt, chinos, and shoes which click on the marble floor – as curated as the spaces around me. Dressed like this I'm often afforded huge amounts of privilege in museums – presumed to be a professor, perhaps, or museum director. I'll be stopped by the public, who ask questions or request a tour. Visitors will even go so far as to ask to have a picture taken with me as I seem to match the quintessential quirky museum brand.

Yet this is only one version of me. Sometimes I visit museums as a tourist wearing sportswear, simply to be in the space without professional involvement. Then, the reactions can be strikingly different. As well as being welcomed warmly, I've also (very rarely) experienced negativity and been profiled by staff as 'potential trouble', and have even been followed by security. One such encounter ended with a member of museum staff pointedly asking, 'Are you OK?' while I sat looking at a picture, presuming perhaps I was loitering with suspicious intent.

For me, this is an important reminder of the power of our identities in museums, that people are at the heart of the museum experience and that museums are deeply contested spaces with the potential to offer vastly different encounters. We have the capacity to be or to present many versions of ourselves in museums, and the power to form our own independent viewpoint. I want

in this book to take you on a journey that destabilizes perceived privilege by asking questions that validate you in forming your own responses.

Museums can be akin to stepping out of everyday reality, or a place to create your own reality. This was the case for me, leaving the UK's busy urban streets and the roar of traffic for the almost alien stillness of the museum. My first encounter was hunting for a T. rex in the mid-1980s, sprinting past 'boring things my grandmother likes' in a local museum to find a real dinosaur and stand in awe. Museums can be cool, almost cold spaces, cavernous, sometimes quiet, slower and usually packed with case upon case of objects crying out for attention. This was far removed from my daily reality of growing up in a working-class background. Museums for me were thrilling encounters outside of that reality: opulent, weird, treasure-filled, full of unspoken social rules I didn't quite understand, slightly spooky and decidedly 'posh'. They offered fascinating otherworldly moments I savoured. As a child and a young adult, I never considered what museums were for; I simply experienced it personally. Now as an engagement specialist, I'm unravelling decades of professional experience (and privilege) to ask that question with you. I seek not to impose my view or be didactic, rather to learn and share as I go.

My story entwines with the narrative of the book. Each chapter focuses on a particular exhibit in a particular museum, and the choice of exhibit reflects a facet of the title question, as well as having an emotional, professional or social connection to me.

Identity can be claimed or imposed within museum spaces, resulting in both positive and negative responses. Despite appearances, museums have never existed as a static collection of objects; rather, they are in a dynamic relationship between the institution, its staff and the visitors. I am a product of this, as are my choices in this book. The multiple identities of those interviewed in each chapter add further depth. To read this book is to meet not just museums' collections, but me and my colleagues, and to go on a journey together. I have learned and grown from the interactions of each chapter. I very much hope to earn your trust as a faithful companion as we travel together.

In asking 'What are museums for?', perhaps it's useful to our journey if I offer a starting point based on my own perception and emotion. In this opening chapter, I'll be exploring my reaction to a museum piece, how it starts our conversation about what a museum is, how the piece continues to impact me and the emotional dynamics that charge human connections to museums. The Angela Palmer artwork/Human remains will act as my thematic anchor throughout the book that I'll circle back to at the end.

Meet the mummy

Today we understand the word 'mummified' as referring to a state that prevents the body from decaying, but to the ancient Egyptians the dead body was always transmuting; what we see as a halt was in fact movement and change. Perhaps it is the museum that has truly mummified these bodies.[1]

Figure 1.1: *Ashmolean Mummy Boy 3* by Angela Palmer

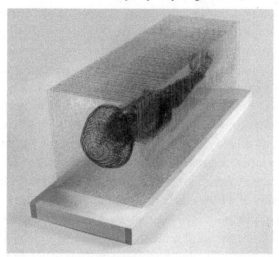

Caption from Artist Publication: The Ashmolean Mummy Boy 3 (lying on his back) is based on scans taken at John Radcliffe Hospital, Oxford. Ink drawing on 111 sheets of Mirogard glass. Presented on a base of sycamore, one of the native Egyptian woods most commonly used in ancient Egypt for all purposes, including coffins (32 × 94 × 30 cm, from a series of 3).

The Ashmolean Museum in Oxford holds an artwork that is one of the most impactful pieces I have ever experienced. It's searing in its intimacy: complex, potentially dangerous, unsettling, yet can simultaneously elicit a response that is tender and caring. It epitomizes for me one of the most successful ways in which museums and galleries can handle conversations and emotions that are capable of distressing us.

Museums have the capacity to stimulate productive conversations and reflections on subjects that may

otherwise be too painful to bear. The traumas of everyday life lie quietly represented in museum collections but hidden under the widespread presumption that museums are safe or inoffensive. I believe museums are places in which we can and do explore these conversations through experiences which, framed by an encounter with an object, can perform the function of serving others. One such experience is the loss of a loved one. [Content notice: the following paragraphs reference the loss of a child.]

In the Ashmolean you'll find the tiny, mummified remains of a two-year-old Roman empire era boy who died of pneumonia around 80 CE. His little bundle is set apart from the adult remains around him, which tell the wider story of ancient Egyptian spiritual belief. Popular culture has rendered the concept of mummified human remains arguably a caricature; surely if it's represented in a cartoon or as a children's toy it must be safe? Our disassociation from the fact that this was once a small person – warm and alive with feelings, emotions and needs – goes hand in hand with our gruesome fascination with performative death as entertainment, especially when wrapped in gilded splendour. Cultural historian Angela Stienne brilliantly explores this in her work and sets us a keen provocation on what it feels like to see mummified remains:

> You may have felt curiosity, fear, concern or nothing at all. You may have returned to see them, being drawn to these human bodies on display. You may feel torn by the viewing of the dead and the ways these remains are displayed, or

you may feel deeply emotional about the connection to
death and the afterlife that bodies facilitate.[2]

Mummification in exhibitions mirrors in microcosm
the function of museums as performative events
themselves, particularly their role in acquisition, display
and reinterpretation. To consider the mummified child,
though, is visceral. The intensity is in front of us: child
mortality is a shocking reality, whether it happened
2,000 years ago or yesterday. The difference is we
have long been conditioned by previous iterations
of museums to think that historical distance means
distance from emotion: institutionally sanctioned
objectification for entertainment and education,
complete with a scone afterwards.

Visitor reactions to this small bundle vary. I've seen
fascination, sadness and discomfort play out across their
faces. However, next to the mummified remains resides
a piece of art by the contemporary artist Angela Palmer,
a reimagining of the child's remains. This juxtaposition
for me embodies one of the most powerful versions of
what museums can be, and how they communicate.

Its exact proportions painstakingly hand-drawn
on glass, Palmer's artwork remakes a version of
the child from CT scans of his mummified remains,
using approximately 2,500 slides and 111 sheets of
glass. Beyond the bandages, we see inside this tiny
anatomy. Through art, the mummy is not only literally
unwrapped, but also unbound from the pop culture
version of the Egyptians. It's not a depersonalized
depiction of Egyptian life; instead, we see a raw

representation of the loss of a child. It challenges us, asking *why* we are fascinated by his death, and how we are treating his remains.

Yet this artwork is not a child – it's inert glass and ink. Presented side by side, visitors can choose to focus on one physicality or experience, both in duality. How do we engage with this child? Via the human remains, the artwork or both? Each is a potential lightning bolt of emotion, yet in different ways, depending on how they speak to us. That spark of connection goes far beyond our expectation of a mute object: it's an emotional encounter. Is that what a museum is at its best? Not dry details on a museum label, a useful toilet stop or somewhere to pass a wet afternoon – but instead a place, an object and a human being forming a personal encounter?

It's vital we consider the notion that museum objects are not by default safe (palatable, secure, contained, cosy narratives divorced from contemporary society) – rather, museums can *increase* how unsafe the object is. 'The Emotional Encounter' could describe not only museum collections, but the very existence of museums in the first place. The combination of an Egyptian child's remains with Angela Palmer's sculpture for me is a touchstone that I keep coming back to, first in terms of applied museology and then a deeper layer of emotional contact with others – be that consideration of mortality, or my own ethics and values. There are very few examples that I have come across with such emotional register where choice has been laid out for me – here, a choice in terms of how I respond to human remains in museums.

If we're starting from the position that pop culture and society render Egyptian remains not only safe but child-friendly, museums displaying them are 'consumable', 'harmless', 'exciting' and divorced from the reality of human mortality. Palmer's work allows me to make a conscious choice: do I focus on the human remains or do I choose the artwork and its symbolism, artistically the child unbound from Western appropriation of the 'mummy' and therefore the society that I grew up in? Palmer's piece makes me question why and how we use Egyptian remains in the first place – notably the museum's acquisition and cataloguing of bodies of colour. Spirituality (the reason the remains are in a mummified state) is seen through a Western-centric concept of a faith that is no longer practised in its original form, therefore unable to be defended by lived experience.

I recall periods I've spent in the Ashmolean, witnessing both fascination and discomfort as visitors process the moral weight of a child's death represented. To see adult mummified remains is for some people part of the routine museum experience. To see those of a child is very different. The scale of the child's anatomy may engender a sense of protectiveness. Contemplating loss provokes a very real emotion in visitors. To help me further understand this experience, I spoke in person, sat in comfy chairs, to Jo Rice (she/her), the Ashmolean's Head of Informal Learning and Public Programmes 2022–23. We started by considering the perception of museums themselves.

'Overall,' Jo told me, 'I think museums are still seen as trusted spaces by a lot of people – spaces for

learning, well-being, recharging and socializing – but this certainly isn't true for everyone. Many people see museums as safe, welcoming spaces to come to … But for some people museums are still seen as elitist and unwelcoming. Returning from lockdown [post-2020 in the UK] I felt there was a real appetite to come out and see the world. Museums are one of the few spaces it feels safe to come by yourself.'

On breaking the taboo that museums are by default positive places, Jo says, 'A lot of people in our experience are quite angry about museums. They're challenging them to change.' And the pandemic accelerated this process: 'Now we've got statements about equity, diversity and inclusion; we're building co-curated practice, it's much more embedded in the way that we work rather than experimental practice. Museums are being challenged and scrutinized around representation.'

She continues:

> The last 30 years have seen museums evolving from education to learning, to engagement, and to a much broader idea about what that might be. Museums got to where we are now by a whole range of people fighting a good fight, developing their practice, championing audiences, interpretation, engagement. Without people, a museum is just a store.

The Ashmolean, where Jo works, is one of the oldest museums in the world, dating from 1683, standardized firstly into academia via the University of Oxford, then

through progressive shifts into the 'brand' of what a museum looks like. Perhaps some audiences feel an urge to come in and surrender as much power as possible: 'Give me the correct version. Tell me what to think. Tell me where to go.'

'The museum is a civic space,' says Jo, 'they are part of community, part of the city. While we need to relate to our collections, some projects make the case for the museum being part of the community as a welcoming public space. It might not always relate to collection.'

I return to witnessing reactions to the artwork and mummified remains. Jo shares:

> Often you see people walk past and turn their heads. They realize it's a body and might ask, 'Is that a real person?'. That allows us to have sharing on the journey from death, mummification, to a museum gallery in Oxford. That's both profound and an intrinsic story of the civic space that can transfer beyond the museum walls.

Palmer's work honours a little life, one that once had hunger and needs. Historically, we are conditioned by society that to express ourselves emotionally shows an inability to reason; therefore it is 'less than', particularly in a historic university setting. To be emotional is to be without reason in a space *designed for* order and reason, an incredible contradiction given the humanity these museum encounters elicit from us. Are we expected to be emotional in museum spaces? Would you go to a museum to cry, for example? Jo ponders this: 'Maybe. I think where there is some real

potential in museums doing a lot more as spaces is where people can come together to have those kinds of conversations. There is a huge amount more that museums can do to promote the social and cultural prescribing model.' Being open to emotion then is one of the keys to our interaction with the art/mummified remains. The museum can widen both our perspective and our ability for dialogue.

As with all museum objects, here we find a manifestation of the unexpected survival. Museums are dependent on us – our interest, lived experience and care. With that perspective, museum objects speak of an original context, but live in ours. The label starts the conversation; we populate it. What are museums for? I return again and again to the artwork/mummified body to help me articulate this. As we shall see in this book, some museum pieces stand out. Not every museum exhibit will spark emotion, but some do have the capacity to move us, perhaps even to contribute towards healing us and fundamentally to help us be with others.

I'll follow the same format in the chapters that follow, first introducing an object, which will lead on to a conversation and, I hope, ultimately shed light on our central question: 'What are museums for?'

2
THE CLASSICAL MUSEUM

Museums are one of the most complex organizations in contemporary society. ... Museums must also provide meaning, value, and enjoyment to a diverse range of publics within the context of changing societal values. In doing so, they must serve two unique communities – societies' ancestors and those who are not yet born. Neither of these museum constituencies vote or consume, and thus have no visibility in commerce and politics. ... In short, museums exist in a world often baffling in complexity and do not have the luxury of a simple profit and loss statement.[1]

How did museums come to be? This brilliant quote from Janes and Sandell reminds us how complex a task both asking and answering that question is – museums appear timeless and unchanging by design. At their best, they can be active agents for change in our contemporary lives. At their worst, they become irrelevant, unable to understand their own past, consider the present or formulate a future. Museums

are part of our lives by being part of society, shaped by lives that came before, agents in our lives today and intended to last for those who follow us. They hover in our shared consciousness, regardless of whether we visit them or not. Never purely benign, museums divide opinion. From dry and dusty experiences rife with boredom to deeply loved emotional and social encounters, their capacity to polarize is powerful.

In this chapter we'll explore how museums came about. We'll consider how collections can form and suggest that they are far from immutable. The selection of museum objects is a political and often a personal act, rooted in the founding of museum spaces. But this is not always explicit. Many of us first encounter museums on school trips and by default accept that museums simply have always been – and, further, that we have no control over them, how museums function, represent us, hold the material culture we care about and are stakeholders in.

This chapter will also acknowledge that museums are contested institutions. They often polarize emotion and opinion, and the stakes can be high. In some cases, for example, museums lack full external autonomy – they can be intimately tied up with questions of legality, nationhood, sponsorship, patronage and global politics. How did we arrive at a position where museums seem immutable?

Our conversation starts at the Grecian collection of a world-famous institution, the British Museum. Ubiquitous in pop culture, Greek sculptural elegance is synonymous with the very concept of a museum.

Using one of the British Museum's statues to tell the story, we explore reactions that collections can inspire in audiences and use this to consider how the identity of the museum came to be.

The face of Alexander

In the British Museum's busy Gallery 27, the face of Alexander the Great gazes out at us as we jostle with other tourists – or is the face looking straight through us?

Figure 2.1: Marble portrait head of Alexander the Great (300 BCE–150 BCE)

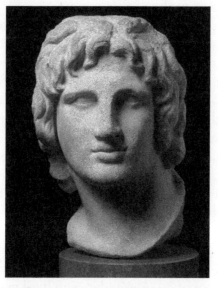

The head was cut to fit into a separately-made body. The surface is in good condition with only minor abrasions. The back of the head has been worked to receive the remainder of the hair, which was probably made of another material, such as stucco or plaster.

The impassive beauty is beguiling. Flawless symmetry is flattered by multiple light sources as shadow and light fall across the static marble, casting a variety of shadows as you move around the piece, giving it a lifelike quality. High cheekbones and a distinctive tilt of the head emphasize this characterization of masculinity – strong, youthful, self-aware and a beauty designed purposefully for our consumption.[2] Consciously or unconsciously, we absorb the perceived high status of this object. Western society equates marble with luxury. It associates antiquity with quality, wealth and elite scholarship. Beauty here is arguably an expected part of the iconography of a museum.

The global West has been conditioned through pop culture (and before that through elite education and museums themselves) to think of Greek and Roman art as a highpoint in the museum experience, an aspirational archetype in marble sought after and reimaged in the development of Western art seen still to this day.

Alexander represents one of the most recognizable manifestations of our expectations of museums. But to see beyond this depiction of Alexander is to look behind the facade of a museum and consider its foundation. Go deeper and the portrait of Alexander is highly sophisticated in its capacity to manipulate us. Its mask-like beauty is just that – a mask.[3]

By the age of 30, Alexander, who lived in the fourth century BCE, ruled one of the largest empires in history. He commissioned many artists to portray him with deliberate political intent. His youthfulness is a form

of propaganda, as for a warrior ruler to age or become infirm was interpreted as weakness. Portraying strength is therefore a literal means of political survival. In sculpture we see a carefully stylized imperial depiction designed to elevate not just the ruler, but a god who was deified in his own lifetime.[4] It offers no promise of accuracy, instead bridging politics, aesthetics and faith with a singular vision – control. As historian Lucilla Burn says, 'None of the "portraits" of Alexander should be regarded as photographic likenesses of an individual; doubtless they bore some resemblance to him, but clearly, they were partly idealised, conveying the image of Alexander that he thought desirable for his subjects to see.'[5]

Youth and strength are weaponized so that the ruler behind the depiction maintains power. We see here not Alexander the man, but a fossilized imagining of beauty, an amalgam of physical ideals designed to emotionally manipulate us within an unequal power dynamic. Unrealistic, unattainable – a cold beauty literally elevated on a pedestal to look up to.

Where once in the ancient world similar sculptures were painted to appear hyper-lifelike in vivid hues, white marble was reinterpreted from the Renaissance onwards as pristine and the original state. Yet it was never intended to be so[6] – this is a Eurocentric and outdated interpretation based on weathered and/or incomplete survival from antiquity and later aggressive cleaning. As the sculptures change from private to museum ownership, Alexander becomes appropriated into the global art and political traditions of successive

Western histories, evolving in propaganda. Alexander's perceived imperial status becomes their own. His empire now serves in the visual identity of later empires. Never intended to be seen in this place or setting, Alexander's face now becomes caught up in contemporary notions of nationhood and ownership.

A collection for the nation

Just as this sculpture of Alexander can be seen from multiple vantage points in history (literally and metaphorically), so too can the idea of a museum. Apply the context proposed in considering our sculpture to museums themselves and the familiar may begin to unravel. 'Museums' arguably have conceptually always been a form of the human experience – the instinct to collect, curate and display objects may be as old as humanity. Archaeological discoveries suggest tangible examples of how humans from the past personalized objects in a group reflecting an early human experience. Goods and artwork, for example found at Blombos near Cape Town dating from 100,000 BP, arguably reflect our ability to gather, collect, interpret, and curate the environments around us.[7] The Western idea of a museum, though, arguably comes recognizably into one way of being with the creation of the British Museum in 1753. In time, it becomes one of the go-to pop culture images of a historical museum we still conjure today – visible wealth, immense status, intimidating architecture, immaculate courtyards and world history codified by time periods.

The British Museum is one of the earliest examples of the merging of multiple so-called 'cabinets of curiosities' or private collections to form a museum. For wealthy collectors to own a piece of history is to add themselves to that history as an act that changes its meaning. Museum collections can be created from these personal acts, in shifting states of private collections that combine or disperse across time.

The British Museum came into being as the bequest of the voluminous collector and notable British physician Sir Hans Sloane: seventy-one thousand pieces, including antiquities, architecture, artworks and books, made the transition from private collection to pieces of (later) shared public ownership. In the founding Act of King George II, not just a museum but *expectation* of a museum is born rooted in the highest levels of privilege.[8]

The singular nature of where a museum can start from is vividly seen in Sloane himself – *his* wealth, *his* art taste, *his* social interactions, political decisions, and wishes are still to this day functioning within UK democracy as the core of a museum in which citizens are stakeholders. Further, this is a museum which is situated within international politics. As former director of the British Museum David M. Wilson says, 'Each generation makes its own contribution to the museum, and it is often the actions of individuals that change its course.'[9]

Via an Act of Parliament which established the collection as a museum for the nation, an example of the museum model we recognize today began a long,

complicated (and sometimes painful) adaptation from private privilege to amalgamating civic identity. A version of 'Ground zero', as it were, for the Western-centric idea of what a museum is that went on to become either sought after or violently imposed around the world via colonialism.

Internationally, we see this evolution of private ownership branching into many different directions, political expressions and uses. Examples include Russia's first museum, the Kunstkamera in Saint Petersburg, formed in part from Peter the Great's cabinet of curiosities. The internationally renowned Prado in Madrid speaks to King Charles III of Spain and his interest in collecting natural history. The Uffizi Gallery in Florence developed from the personal collection of Cosimo Medici and was added to by the famous Medici dynasty. Austria has the 'Wunderkammer' of Archduke Ferdinand II.

Museums and control

Museum history demonstrates the porous nature of social change. A 'restricted member-only and subjective encyclopaedia' may be a more apt description of the early museum model. Arguably, it's a physical manifestation of the eighteenth-century Enlightenment movement which sought authority, classification and a 'rational', scientific catalogue of the world. Within museum walls, global cultural variation is forced (because of unequal power relationships) to fit into a museum structure that directly mirrors the limited

lived experience of those in control of the museum. We in turn start our own museum experience with an inherited expectation that the label will accurately describe what we are seeing, and readily believe in its projected high status and scholarship. It *must* be correct if it's in a museum – surely?

There is a direct correlation between colonial violence and the expansion of resources available to the Western museum model. In one of the most visible manifestations of global inequality, some museums acted as the civic receptacle of power and colonial subjugation. Within that violent privilege, why would contemporaries need to travel to see the world when they could bring a curated version of it to their own European city? The cabinet of curiosities model becoming a museum is a staggeringly painful model that we still live with today, seen through empire and its ongoing damage. The historical process of acquisition is a broad spectrum of legal and illegal, moral and immoral.

For some (though not all) historical museums, equality and access were arguably never intended as founding concepts. Museums are inherently contested entities. We see this not just in the collections and how they were formed, but in their governance. Museums' civic function is a powerful mix of competing forces – the British Museum, for example, is governed by an Act of Parliament from 1963, directly controlling decision-making on the collections and the option of returning contested objects. So significant is the collection to UK politics and national identity that it's regulated in law. Add to this thorny questions around

sponsorship, paid entry to some attractions, private donation, corporate income generation, grant funding and state funding and we find a deeply complicated picture of museum autonomy.

The earliest version of the British Museum demonstrates the authoritarian nature of museums at their founding – at its inception, for example, men were the expected primary audience within a patriarchal structure. Access to the collection was by appointment, networking, wealth or scholarly request. 'Entry for all' was arguably a deeply ambiguous ambition in an unequal class structure, therefore the museum model that later institutions are built upon had no expectation (or need?) to be egalitarian. Viewpoints on culture were regulated and never intended to represent the lived experience of the societies from which these museum pieces originated. Privilege reinforces privilege – cultural status grows, controlled by access and exclusion. Much like our sculpture of Alexander, some museums have both a mask of initial perception, and a structural/historical reality of control at their inception. What could be more attractive to a museum emerging within eighteenth-century imperial power than the Hellenistic visual template of a previous expansive empire and its propaganda? Museums are not neutral. They never were intended to be.

Museums occupying the present

Duality thrives in museums. While for some they are sites of violence, for others they are beloved

and integral parts of their emotional landscape. The continued popularity of and footfall in museums show the deep affection, fascination and investment people have in them (the British Museum had over four million visitors in person during 2022, as an example). They are perceived (by some) as caring, comfortable, benevolent and reliable mainstays of culture. That affection is very real to those who feel it and should never be diminished. Yet others will never engage with a museum – they are a source of too much pain and alienation. Arguably, for some they are simply not relevant. It's a duality balanced by those who work with and within museums, offering a useful viewpoint to explore.

Let's apply this conversation to the experience of two engagement specialists at the British Museum. Ashley Almeida (he/him) is the Greengross Family Young People's Programme Manager, and Maria Bojanowska (she/her) is the Dorset Foundation Head of National Programmes. Both offer via their museum engagement work fascinating emotional and intellectual insights into the duality of a museum navigating both its past and potential futures. Both were interviewed in person at different times at the British Museum offices. Our window looked out onto the huge main courtyard, where a long line of visitors gradually filed through security.

Museum participation is a product not only of their foundation, but also of our own rapidly shifting social landscape. Undeniably they are huge tourist attractions, yet they hold deeply emotional narratives that have the

capacity to draw us in, alienate or reject us based on lived experience. Are museums aware of this?

'Instead of museums saying, "Why aren't these people coming?", now they are asking "What do we need to do?". We need to answer to the things people are interested in now to maintain relevance,' says Ashley. 'Museums are at a strange place of trying to work out what their place is within society and trying to evolve. As a sector it's slow to move. [Museums] are on a catch-up trying to understand our audience.'

Maria picks up on the theme of museum identity:

> I don't think for the general public there is an expectation of our spaces as changing and dynamic; unfortunately, the majority of the millions of museum visitors that come through the door will only see the permanent spaces once. They will likely think of it as a version of that 20-year-old encyclopaedia that's static, as a means of saying 'how it was' and educational. We're challenging that. I do believe the general public trust that museums interpret the collection accurately. In terms of critiquing that historically, it is very difficult for our displays to be always open for a dialogue.

Audience expectation here is key. Maria says:

> The museum audience may think that there's a sense of ease, that challenge isn't part of their experience. For some, it's a day out. They will have paid, at least to get to the museum. It's on the tourist list, a site to see rather than what we also know it to be, a tightrope of two worlds.

A fun day out with the family vs a huge, cavernous space of complex emotional stories.

As Ashley says, 'Museums have the potential for solutions rather than repeating bits of history. Previously, museums haven't been looking to collections for solutions.'

The museum identity crisis

With Ashley and Maria, we move to consider whether museums articulating multiple viewpoints and their own history is a vital part of articulating what they are for today, and how they came to be. Increasingly, museum practitioners recognize that audiences don't want one definitive answer within collections – they will find their own solutions and expressions as to what the museum is and what it holds independently, using the collections without museum dialogue, thus revising the perceived power imbalance to a degree.

What gives, then, in the shift from where museums started to where they are going? Is it in how museums express their identity and purpose? 'Museums can be many different things to different people,' says Ashley. 'To some they are a community space – it can be places of event, or interest – but I think museums want nice, neat answers to their identity so they know how to engage. This is where the problem is. It's never going to mesh. Museums should be able to be more reactive.' Why then are museums slow to react? 'Because

they haven't done the thinking on this. Because of a privileged position and slow start, they must quickly do hard thinking in a short space of time.'

Perhaps, though, as with any crisis, there is also opportunity? Maria says, 'I would want everyone who walks through that door to have a different motivation for why they are here and to have a different perception of what this place means to them, and the experience the objects have with them.'

Othering at the core of museums

One manifestation of museums' history that they are still grappling with is encapsulated by the notion of 'othering', to be made to feel 'other', or an outsider, in a museum. Museum professionals are often in the front line of these potentially painful histories. Were museums initially designed to be of service to diverse communities? 'No, repositories of objects that were different to what [Western-centric communities] were used to, set up to "other" people,' says Ashley. 'Museums have objects that come from this position, we must own up to that.'

Applied to our sculpture of Alexander, othering is also an emotional experience for Maria: 'For me the sense of weight of an object is that it's so profoundly reflective of humanity. Hellenistic art can be an idealized version of humanity.' More broadly, she says, 'You look at things that are seemingly impossible in their existence, the scale, the material, the age, so many factors make them otherworldly. Unfortunately,

it engrains that sense of "otherness" in us.' On how museums 'other' based on privilege, she adds:

> Power for me is such an interesting part of what I do, and I reflect on it a lot. I reflect on it not just on how museums are and what they represent in terms of agency, but also in individual cases of the relationships we have with colleagues across the sector.

If the act of othering is in the DNA that created a museum and its collection, perhaps museums' future lies in accountability and care with conversations around othering?

Societal change

Examples of work done at the British Museum on youth engagement and engagement with national touring exhibitions show that there are deeply ethical ways to challenge the inequality that some may feel is baked in at the time of founding. Are we locked into where museums started? 'We don't have to be,' says Ashley, whose work includes platforming different objects and where they came from to give a different perspective on them. 'Young people now are much more articulate in asking the difficult questions. They have questions, they want answers and when they look at the collections, they see things that are interesting but don't represent them.'

This includes the sculptures of Greece and Rome, as Ashley affirms:

They want to look beyond and have stories they connect with, know of, or just want to talk about. Many of their choices are from non-Western perspectives. [In a piece of engagement on museum interpretation in 2022] one chose a bust of St Francis Xavier which talked about the influence of Western policies on the Philippines, and how there was a beautiful story about two moon gods who fell in love, and this story being around queer relationships in mythology, but all these stories become lost in Western policy. The group were keen to choose non-classical objects; they wanted stories that weren't being told.

For Maria, the ability to engage with the collection nationally, not just in London, is a powerful driver for continuing museum change:

We can be reactive, we can pivot and change. One thing we are lucky to do with our national programme is on depth of meaning. The museum can almost offer a 'tombstone definition' of an object in 80 words. Whereas we can pull out one object in our spotlight programme and give it the space and breadth it deserves. It has its own story and presence. To give it space in national touring is to give it that depth. It's still limited, but it's an opportunity to create space for complex emotional stories when visitors have had a chance to have 'that moment' with an object in their local museum. Spotlighting objects is different.

On the emotion of change in museums, Maria says, 'We are always so careful to ensure that even if the

experience isn't entirely positive because of the subject we explore, the audience feel supported in exploration.'

What are museums for?

Ashley offers:

> Part of me wants to say museums can be anything you want them to be but that seems flippant. It doesn't consider that some people really do find museums traumatic or intimidating spaces to enter and navigate. I don't think there is a simple answer. The answer is partly from the audience, but it must be led in a multitude of ways that are intersectional. It should be an ongoing question met with flexibility and reaction by museums to try to express what their function is. Young people are important parts of this conversation. They want and need answers to create futures. If we don't engage with them now, why should they come to a museum in the future?

Maria says that, while she would never call a museum an entirely safe space,

> what we can achieve is to welcome everyone to be part of a shared experience. To feel part of something. You want to feel you can have a connection – there is so much more museums can do. To make connections with people and objects' physicality as we go more and more into the digital realm and connecting without being at the museum. I see the partnerships status of our museums across the country changing and within their unique roles

locally repositioning national collections – I think the British Museum is (for some) only trusted because we are working with that local space. That's where trust can be deepest.

What do the public think?

To be present in the space with visitors is an opportunity to ask this question, of what museums are for, in each location visited. No one testimony is demonstrative of a combined audience reaction, but shared narratives recur in conversation. One such was directed to the author when asking the question at the British Museum. The reaction was telling. A family group of tourists had travelled a significant distance in the UK specifically to visit the museum that day. Rich conversation took place between the author and this group near the sculpture of Alexander. Approaching the author, they ask about the book research and the chapter in focus. 'Are you *allowed* to ask what museums are for? Won't you lose your job if you do?' one visitor asked with a twinkle in their eye.

Perhaps that's what museums are for – places in which we can vocalize and harness agenda. A way to visualize 'soft' state power, and in turn galvanize our own power as citizens.

3

THE MUSEUM IN SERVICE OF OTHERS

Figure 3.1: Ford Madox Brown, *The Last of England*, 1852–55

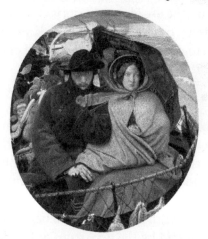

This is a painting about emigration; the couple are departing for Australia. The subject – departure in desperate circumstances for a foreign land – has parallels with the biblical story of the Flight into Egypt. The artist himself posed for the painting, along with his partner Emma, and their children Cathy, the girl in the background, and Oliver, the baby.

The verb 'to care' shares its etymological root with 'to curate' (Latin; curare – to take care of). Safeguarding and stewardship are the basis of this care, with curators as keepers of the collections.[1]

Museum collections fundamentally need people more than people need museum collections. 'Curator' is not just a job title for the few who work in museum spaces; we are all potential curators of our own experiences.

Without our interaction as visitors, museums are elaborate storage and conservation centres. The museum exists to engage with society. Considering that concept of service, here we ask how museums function for others. For a museum to simply look after objects is not enough – the use of the objects is crucial to realizing their value to others. That use takes place within a rapidly changing framework of societal expectations.

Our Piece in Focus

How does this manifest itself? Our stunning example is Ford Madox Brown's *The Last of England* (a high-profile part of the collections within Birmingham Museum and Art Gallery, an institution internationally renowned for its collection of Pre-Raphaelite art contemporary with Brown). Brown began the painting in 1852, inspired by the departure of his close friend, the Pre-Raphaelite sculptor Thomas Woolner, who had left for Australia that July. Emigration from England at that time was at a peak, with over 350,000 people leaving that year. Brown, who at the time considered

himself 'intensely miserable, very hard up and a little mad', was himself thinking of moving to India with his growing family. Our chosen artwork therefore is rooted in a global narrative on migration – the experience, the act and its emotion.

Two figures face us in this dramatic scene – the male-presenting figure is based on Brown, while the female-presenting figure is his wife, Emma. The contrast is startling: the perceived anger and determination of the man, versus the apparent passivity of the woman. Each is dressed in contemporary Victorian middle-class clothing. The white cliffs of Dover recede behind them as they take to sea, though neither looks back. Packed around them are an assortment of 'characters' – travellers of different classes sharpened into caricature or Victorian morality devices.

Examples include 'drunken' men, the 'vulnerable' elderly and the 'virtuous' family. The child eating an apple was possibly modelled by Brown and Emma's daughter, Catherine. A baby concealed under the woman's cloak in the foreground, and whose hand she is holding, is perhaps a reference to the couple's new child, Oliver, or more generally symbolic of the start of a new life. Irrespective of origin, all are bound for a new life. It's a florid piece, arguably overtly sentimental and moralistic, yet bursting with a powerful narrative on belonging and the bonds that bind us to places and people.

To help read this piece I spoke to artist sophia moffa (they/them), founder of the travellers' tree CIC, an arts organization working with asylum seekers in Birmingham UK. It organizes art, nature and outdoor

activities for asylum seekers in refugee hostels in Birmingham and the West Midlands. sophia's starting point is the idea that this art story is not locked in the past: people today have lived experience of migration, and it's an evolving conversation.

One strong narrative here speaks about endurance. The boat has taken to sea during a storm. Rain lashes the umbrella and soaks the passengers. They're only just setting out; an arduous journey of many weeks lies ahead. Stoicism is both a practical and moral statement – the woman is red-faced and flushed from the exposure but impassive, looking ahead, whereas the husband adopts a far more aggressive, determined pose. sophia underlines that "they are in limbo. There's no turning back and you don't know what's forward. But you keep going. And I think everyone's true self comes out in these moments."

History does not mitigate the layers of pain within the museum setting. Perhaps some may find this a 'safe' context to consider such a huge moment in the lives of our sitters because the migrant narrative here is historical and contrived. They're 'finished' – fictional, static, and remote from current danger. Museums, however, can be of service to other people by highlighting/reflecting these stories and considering them through the lens of contemporary advocacy. sophia imagines how:

People can come in and say, 'It's a nice picture.' But then usually the description is what gives the context. When a museum describes a picture, that's a political act; interpreting

it for others is a political act. A lot of museums try to stay away from politics or having an opinion. Usually, people come in and read the label and think 'that's the truth', 'that's how I should interpret it'. But these institutions just need to acknowledge that maybe they don't know the best thing.

So, can this artwork be a tool for advocacy for others? sophia suggests:

a museum can be a tool for advocacy – I'm not sure if a painting can, it depends on how/who interprets it. I think that Britain tended to hide the truth of the catastrophic effects of colonialism, and this painting can evoke emotional feelings for someone/something that was truly a lot worse for the country they were travelling to.

sophia expands this to ideas of civic care:

I think every place has a civic duty to have conversations on how society changes. But they must represent the whole community, not a section of the community. I understand that the work to change all of this, to represent the whole community, is extremely hard work. But it needs to be done. Because the generation that's just younger than us are way ahead of us. They won't stand for this. They are way more knowledgeable; they are way more respectful. They are way more conscious about how we should live.

A reminder that historically what's been lacking in Western museums are non-Western perspectives, sometimes reinforced by an art/ethnography distinction

depending on where objects come from. Representations like Ford Madox Brown's offer no other voices around them, and yet come to represent the museum visually. Apply the lived experience to the artwork in its location and the work changes fundamentally – it's a conversation around home, a large narrative that everyone can connect with on some level. While fewer people have the experience of migrant crossing like this, we all have experience of the concept of home – having one, perhaps being without one, considering what home is, whether home is people around us, whether the home is geography, home is faith or home is our body. One power this painting may possess, depending on how it is presented, is to unsettle the settled – perhaps by visually using people from Britain who risk starting a new life somewhere else?

To access a museum as a visitor is intersectional – we are a multitude of characteristics, states of being and facets. While one motivation or identity may present in the foreground as we enter, we cannot and should not be defined by a single state of being. 'Once you start helping other people, you start seeing all the different layers,' says sophia. Perhaps then if we view this piece in its capacity to help others, advocate for their rights/feelings, foster emotion and togetherness, it's transformative.

Identity and care

Following on from sophia's generosity of sharing, we can expand this reflection further with two guests interviewed separately online, who help us follow

thematically the journey foreshadowed in the artwork itself, from England to Australia. Sara Wajid (she/her), Co-CEO of Birmingham Museums Trust (BMT), which holds the Ford Madox Brown piece, and Craig Middleton (he/him), Senior Curator at the National Museum of Australia. Both offer powerful perspectives on civic care, museums in the global North and South, and the notion of museums being of service to others.

Sara begins:

> A lot has been written about the divisive culture wars and I haven't found them to be the reality on the ground. I think that discourse is useful to certain parties to stoke their agendas and that they have been retrogressive: policies, particularly around 'retain and explain', and other kind of policies have been seeking to control creative and curatorial practice and to control the national narrative. This hasn't been true to my experience of people's actual view of museums. It's not there that are no divisive feelings or that people don't have very mixed and strong feelings about museums as symbolic spaces. But it's not nearly as widespread as you might think if you read the papers. I think that overall, people see museums as sites of resistance, but also sites of healing and escape.

Birmingham as a geography has a very strong civic identity, but how that manifests is vastly different according to where you are in the city and what Birmingham you are experiencing. A museum can be symbolic of a sense of self within place, a way of accessing the identity and character of a city.

Sara offers an example: *The Museum of Us*, a television programme BMT recently collaborated on, in which, over the course of a week or two, people who lived on a particular street curated an exhibition about their history, which became a pop-up exhibition:

> We partnered with residents from Somerset Road in Handsworth, Birmingham. Members of the museum team and collections were featured in the programme, but the stars of that show were the residents of the street and the objects from their homes. For instance, there was an elderly Ukrainian-Polish woman who had been a seamstress. Her entire sewing room was recreated. Would this have traditionally been exhibited in the prestigious museum space with grand paintings and so forth? No, but I think that the founding fathers of the museum would see that it's the same principles that they were working to, which was for everyday people. That there should be cultural enrichment and the collection that belongs to the city, is in the hands of the people of the city, and it's supporting the social fabric.

Ford Madox Brown's painting offers an interesting way of pulling together some of the strands that we've been talking about – it's ironically 'Birmingham' in terms of civic ownership, a huge commercial asset for tourism and quintessentially 'Instagrammable' as a social media experience. Simultaneously, it's symbolic. It contains a startling narrative on migration, journeying to and from this city, finding and considering home.

Let's widen our geography and consider another viewpoint. As the painting sets us on a migration

journey, let's consider an Australia perspective with Craig, and the legacies of migration. Just as with Birmingham in the UK, the National Museum of Australia offers ways to consider civic status, belonging and how this manifest in museums. Craig says:

> In an Australian context, museums are still considered to be one of the most trusted institutions in the nation. ... A persisting trusted voice of knowledge and authority, which is interesting, given what a lot of practitioners are attempting to move away from that voice of authority and bring in the voices of others. There is still this idea that museums in this country are trusted for their dissemination of information. It's important to know that the National Museum of Australia is also legislated, and it's governed by an Act of Parliament. One of our core responsibilities is to remain impartial, which can be challenging. It's interesting in the context of the work that we do, particularly with First Nations communities when on the one hand you have government policy mandating one thing and then voices of First Nations people advocating for something else.

Australian identity is so specific in terms of the global South not only in its positioning, but also in terms of articulation of self, and the story of colonization. Craig expands on this:

> Nationhood is important in this context – Australia has borrowed its governmental system from the UK. That's how we understand governance in this country. If we consider

the colonial perspective, the colonies all have a museum or a state museum. Those museums were about nation building, asserting a particular position and 'progress' (a very Western ideal to work towards). The concept of creation and 'betterment', but also the enforced template of empire as a civic structure.

Are museums manifestations of care?

We now pick up directly on care and what museums can/should do for others. Sara offers:

> The spectrum of human experience is very wide, and I don't think museums need to or can nanny our emotions. The challenge ahead is that Birmingham Museums Trust have connected with collections that represent living memory and we've done it mainly using social history collections. The much more challenging question is how to reinterpret historic artworks like 'The Last of England' that a lot of people (if supported) can have a very deep engagement with. The next step is to try and work out how to achieve the engagement we have with pop-up displays for a portion of the population, but instead for everyone and with the whole breadth of the collection, including historical fine art.

The future of the museum relies on the collections, their context and their social history being socially adaptive and responsive to social care. Maintaining the museum so that the roof doesn't leak is vital. Just as vital though is that museum collections receive that same level of care in terms of context. Museums are generating and

creating new sociology with which to honour and care for people – people who have in some cases dedicated their stories to the museums. In turn, museums need to keep updating themselves in terms of their sociology. The museum is symbolic of a sense of self within a place, a way of accessing the perception of a culture of a region and its character. Cities are often characterized as fast, boisterous, 'naughty', big and loud, but can also be warm places of belonging and responsive to so many different identities. To go to a museum collection that is so expansive is arguably a process of understanding that and finding space within a city.

BMT was directly set up by a Victorian local government to be an example of civic care, to have a civic function. Reflecting on the Ford Madox Brown piece, it's powerful in duality – a Birmingham city asset commercially and yet it speaks to narratives on migration – journeying to and from this city, finding and considering home.

The perception of museums as 'comfortable encounters' belies the lived experience of those recently arrived by migration seeing this piece for the first time. Museum collections have the potential for pain, which many within museums may not anticipate or appreciate. Craig comments:

> I think museums today have evolved and grown,
> but absolutely the concept of a museum is rooted in
> colonialism, it is a colonial institution and to say otherwise
> is for me problematic. Ultimately colonization is still
> happening in Australia, because of the structures that we

uphold. I'm not suggesting a need to completely eradicate institutions or completely eradicate the past – for me it's not productive to remove any of that or erase anything done to the marginalized.

A reminder, perhaps, of how much our Ford Madox Brown artwork is reliant on people more than they are on it – one perspective simply is not enough or will fit all. Communities (in multiplicity) will find solutions artistically, visually and in terms of togetherness that don't involve museums, therefore fundamentally lived experience brings museum objects alive and finds purpose for their survival in advocacy. It's not just about housing objects with rigorous neutrality. It's about taking the concept of a museum and using it for the advocacy of others. Craig reflects on this:

The only reason anything in a museum collection is significant is because of a meaning that someone has applied to it. Without people, that significance wouldn't exist. Significance is a problematic framework but I'm thinking in the broadest kind of ways including science and natural history collections. Those collections can't be taxonomized without the taxonomy that was created by a human. Human understandings of the natural world or science without people doesn't make sense.

He continues:

Looking to the future, there's aspects of things that I would like to imagine – embodying multiple perspectives, multiple

understandings of the world, creating or presenting rather messy narratives that don't have linear progressions that we're so attached to. We often talk about documenting something of this moment for the future, but we're not really engaging with complexity or messiness; we're trying to create simplicity out of what we know. Museums today are less of, in my opinion, a product of the past and more of focused on making sense of where we are now. What we present is a very contemporary interpretation of the past, which in many ways is engaging with the idea of what people need now.

The idea of the future museum as an emotional encounter starts from the moment of contact with a museum, and multiple identities at intersection with each other globally. Craig offers a powerful example of this:

Australia is increasingly becoming one of the greatest homes of restitution from across the Western-centric model. Many people still believe Australia as a nation began in 1788 and there is this fascinating cultural phenomenon where people are proud (not that they should be unproud) but that they latch onto this identity of pride around being associated with a convict. It has become mythologized in Australian history and there's something around nation-building and identity in that. In Australia it would be considered unethical to display human remains without it being informed by cultural protocol and policy frameworks around how you go about that. In many circumstances there are requirements

for consultation with First Nations communities regardless of where the human remains derived, so for example if you were to display mummified Egyptian human remains, we ethically must engage with local traditional custodians about what that would mean.

A strong example of museums in dialogue on care, taking the functional aspect of what museums were founded to do (collect and interpret) but using it in the direct advocacy of others.

What are museums for?

Sara offers:

I think that we face (not necessarily on a day-to-day basis) an existential crisis of being alive. Fundamentally, the human condition is plagued by thoughts of death and 'Why are we here?' and 'What is it for?'. One lifetime isn't that long, so we need to build on the stories, the understandings, the folklore, the myths that we have been generating since humanity began. We pass this on from one generation to another – learning and knowledge which you might say can make sure a way of doing is through emotional maturity.

We need shared and invested stories that are woven thick in texture. There is a kind of primal urge to have collective stories, understanding and meaning. I think the collecting of 'things' – be it steam engines or pebbles that we found on the beach – is a fundamental urge to save our world. These are the things that matter and that we value.

To have collective objects is just another of the many ways that we've chosen, particularly in Western culture.

I come from a very chatty, Punjabi, rich oral tradition. That tradition doesn't work over every time and place, and particularly not in Western modernity. I keep talking about Western culture because I'm so conscious that I'm from a place (Pakistan) that doesn't really have a museum culture. Museums are an invention, a technology of Western modernity. In this context, it's just one of the mechanisms that we have alighted on that enables us to tell rich stories from generation to generation using emblems and keepsakes that help us. They're props, helping us tell the story of ourselves projected forward into future generations that might help them live and flourish.

Craig offers:

People like me [queer people] enter museums and hope to feel a sense of belonging. I want to see people like me, and I want to know that other people like me will be able to feel a sense of belonging in their life, that I didn't feel for so long. There's a very functional role for museums in helping people find meaning and belonging in their lives. People, at the end of the day, are selfish (not in a negative way) and they (we) want to see themselves. If a museum can be useful for the people it intends to serve, for me that's all about being led by others.

Perhaps, then, museums are complex physical manifestation of our need to tell stories, and in turn a testament to the power of our stories. That to recognize

the human condition is to recognize we will curate regardless of museum spaces but that, through them, our stories can support others. Perhaps museums are one way in which we can offer *care*.

4

THE DIGITAL MUSEUM

Figure 4.1: Boiserie from the Hôtel de Varengeville, Paris, c. 1736–52, with later additions

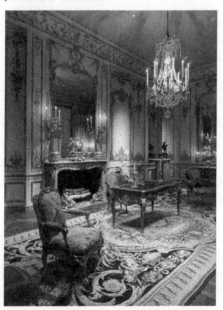

View towards north-northwest corner of boiserie including carpet and writing table

Constituencies are fluid, mutable, protean. They grow
change, adapt, hybridize according to the circumstances
and need.[1]

Without digital access, contemporary museums and
galleries are not fit for purpose. Here we consider
what it means for a museum to exist beyond physical
walls as a digital presence. The COVID-19 pandemic
demonstrated that, with physical access to museums
off-limits, digital access could no longer be viewed as a
lesser alternative to the 'real' museum. Rather, digital is
a reality in itself, and should not be measured directly
against the physical experience of museums. So, what
does museum digital innovation look like?

Finding home in a museum

As we saw in the previous chapter, the concept of
home is deeply personal, bound up with emotion,
place and geography. Museums often speak to us
of this. We see elaborate displays of interiors and
domestic items that once made up the landscape of
someone's life. Two ironies jump out, though. First,
museums can often showcase the material culture of
the one per cent – the economic elite; intellectually,
emotionally and literally, it's a lifestyle unachievable
for most of us, and therefore challenging when we
bring our lived experience to the space. We are dazzled
by its grandeur, perhaps overwhelmed, or alienated,
knowing our notion of home is not this reality or that
we may be viewed as less-than. Second, museums are

often surreal experiences of engaging with home –
augmented realities of interiors and the people within
that are designed to be performative and public: the
antithesis of private.

One opulent example of is found in gallery 525
of the Metropolitan Museum of Art's (The Met's)
international collection in New York. As the most
visited museum in North America, its reach and scope
to connect is momentous.

The elaborate boiserie (wood panelling) of 1736–
52 comes from the Hôtel de Varengeville, a private
residence in eighteenth-century Paris, which still stands
at 217 Boulevard Saint-Germain. Rococo exuberance
dances before us in sprigs of flowers, scrollwork
and trophies. Dense layers of visual symbolism
speak of pleasures within the home – gardening,
music and nature. Yet this mixes and swirls with
symbolism associated during the period with military
might, aristocratic glory and reflections of colonial
dominance. Fashion and choice operate as a visual
language of privilege. The room as recreated literally
sparkles with light through mirrored surfaces, pulling
our own image into this alienating glamour and making
us one with the room. Echoes of indulgence and a
cocoon of wealth surround us – it's not too hard to
imagine the swish of silk and lace, the smell of perfume
and smoke. It radiates institutional elegance, wealth,
potential superiority, and escapism.

Yet it's a curated set piece of a home that *was*, not
that *is*. Residency is denied – the pieces are barriered
off. The humanity of the scene is imagined, not lived:

preserved for visual consumption, not occupation. That is until a small, yet very human, moment of interaction is shared by the digital team: a piece of popcorn was spotted by a visitor inside the exhibit, next to one of the chairs in the Hôtel de Varengeville display. An accident? Or did someone do the unimaginable … jump the roped barrier, sit down on a museum exhibit and have a snack?

The digital power of the personal

Digital content offers a variety of ways through which museums engage – information, articles, films, augmented realities, curated tours or livestream content. It occupies a unique role in how we access museums like The Met. Content and consumption are designed for us on the move or at home. They can alter our atmosphere, our mood, or even our personal spaces. Therefore, the way we consume museum content, our reactions and how we engage will also be different from one another.

The Met Unframed and Met Stories are two examples of content made responsive for digital access. The Met Unframed, from 2019, is a staggering technical undertaking: a virtual reality experience that's a walk-through of 30,000 square foot of museum digital spaces, including 46 immersive experiences. It's had one billion total impressions, 22,000 hours of engagement, and 700,000 visits from 140 countries as of 2021. Met Stories from 2020 takes this further – a series of films exploring personal and professional responses to the

collection. The series has had over five million views, over 200,000 hours watched and an above-average dwell time for this form and length of digital content. While these figures do not speak on the varied reactions all museum digital content inevitably receives, it does demonstrate a remarkable reach.

Both examples are statistically demonstrative methods for engagement, personal agency and access. Digital storytelling, access points and custom-made museum content has transformed (and continues to transform) how we access museums, and in turn their function. The COVID-19 pandemic dramatically highlighted both the necessity of digital access and social relevance of digital access when museums closed their physical doors. When and how could they open again? How would the collections be accessible, relevant and useful? The pandemic upended an assumption that digital content was secondary to, or perhaps lesser than, the in-person museum site experience. This assumption is rooted in privilege, hierarchy and arguably ableism – previously access assumed: (1) you could afford to go; (2) you wanted to go and (3) you were able to go to the museum in person. During the pandemic, digital access was the *only* museum experience. A transformative moment where museum digital engagement became central to access and a museum's reputation. In a real sense, museums were in the home, as were large swathes of the population in lockdowns. Does that, though, create a new dichotomy? Does digital become a tier of its own, depending on its own form of access and reinforcing further division/inequality in access?

Does digital mitigate a lack of privilege, or uplift a new form of privilege?

More broadly, digital access is international, crossing language barriers, borders and time zones. Translation is immediate, a commute is through Wi-Fi connection rather than by aeroplane. One example here is MASP in São Paulo. The Museu de Arte de São Paulo is a non-profit museum in Brazil and the country's first modern museum design, noted for its artworks placed on clear, raised glass easels. This effect of 'hovering' in mid-air is harnessed online meaningfully with a virtual tour you control, with the physical and digital using a shared aesthetic.

Who dropped the popcorn?

With this in mind, we return to the piece of popcorn featured in the MET Stories episode 'Home'.[2] Consider the power of hearing this story digitally during lockdowns when many people were at home.

Within the sparkling wealth of the boiserie from the Hôtel de Varengeville, the fantasy narrative is disrupted. Someone from our time has entered a space absent of both life and people, locked in state of preservation. And this person has done something deeply relatable: possibly had a rest and eaten a snack. The ordinariness of this jars with the pristine elegance of the space, breaking the curated spell. In an environment some may feel is exclusionary, elite and lacking humanity, someone has had a very human moment and left a transgressive personal

trace. In a real sense, many visitors will have more in common with the piece of popcorn than the Hôtel de Varengeville. Who jumped the barrier? How did they get past security? Were they a member of staff operating out of hours and out of view? Why did they do it? How did it feel? Emotion swirls around a tiny moment of occupation.

The digital team uses this questioning in active agency for others; they include the popcorn anecdote in Met Stories to explore the family who found it and their sharing. This forms new content and conversation for others. Sharing this doesn't condone breaking conservation and safety rules, or antisocial behaviour; rather it illuminates a deeply human moment that personalizes an otherwise otherworldly scene. A small yet meaningful example of digital storytelling defining the function of museum spaces that's intuitive, human centred and accessed remotely from the museum.

In such an alien environment, we are reminded of the power imbalance between institutions and visitors, how much agency we give away as we enter. Met Stories and The Met Unframed challenge that dynamic in a chain of events. The visitor starts with a museum space that fetishizes the concept of home in a public setting. They then rebuild the concept of home in a private digital setting. Augmented realities of home become *part* of home via electronic devices within our intimate landscape.

Digital ethics in museums

Let's pick this up in conversation with two professionals who developed this content at The Met: Sofie Andersen (she/her), previously Chief Marketing and Experience Officer (and former Interim Chief Digital Officer) of The Met and now Chief Marketing and Experience Officer at Brooklyn Museum, and Sarah Wambold (she/her), Executive Producer and Content Strategist. Each was interviewed separately online. We start by reflecting on 2020, the massive engagement with Met digital content and the development behind it.

Digitizing such a huge space is an enormous undertaking. As Sofie said:

> 30,000 square foot. Kind of sounds daunting, right? Particularly when you think about how much space they're covering there. The reality is that a lot of those virtual galleries were custom-made for the purposes of Met Unframed. It's one of the things that is very cool about it. It doesn't seek to recreate; those galleries as they were configured don't exist in real life. They were created for the purposes of an experience that people could manage using an app as opposed to walking through the galleries every day for a year and still finding new places. I think it was a huge success in terms of raising awareness that museums were back and open (post-lockdown). However, it wasn't necessarily that everyone was ready to come back. So, offering an alternative and saying, 'You may not be ready to come back into our spaces, but here we've created something for you, wherever you are in your space.' You can download the AR experience and

have fun with placing objects in your home. In some
ways, it's flipping on its head the narrative that coming
in person is the best experience. Here's something that's
telling a different story to the public and embracing
this opportunity.

In-person interaction was, until recently, the only way
for institutions to operate. This is the dominant metric
by which we understand museum engagement: in terms
of cultural hierarchy, the physical experience is superior
and generates more funding. It fails to recognize that
this experience is governed by the financial, emotional
and possibly ableist privilege of being able to access
those spaces – and the presumption by institutions that
people want to be there in the first place.

The museum is creating an exclusive digital
experience that has the same value as the physical
on-site encounter. In another clear and elegant example
of digital not being second best, Met Stories captured
the lived experience of museums. Sarah reflects:

> I very much saw my role as trying to clear the path for the
> brilliant producer who was working on it [Sarah Cowan]
> to make creative decisions and her vision for it. [Met
> Stories] is about why museums are important to people.
> It's not about The Met. It's not about 150 years or about
> any museum piece in The Met. It's not about the experts
> or the research. The Met has a long history of saying
> why museums matter in an institutional way. It's important
> to democratize spaces or have conversations about
> humanizing the institution because I think, in our minds, it

really was about the people. We were able to stay focused on that as we were producing.

Sarah continues:

It became potent in the shutdown. We had already produced about six episodes before the [2020] shutdown happened. We were in this position where we had defined the series as being of very high production value with beautiful camera shots designed to elevate voices from outside the institution. Then, in the shutdown, we couldn't film on site anymore. We asked ourselves: 'What are we going to do?' How are we going to continue to produce this? *Can* we continue to produce this?" In the first episode, we were using multiple cameras and shooting from different angles and nice lenses. Then suddenly, we're using mobile phones, AirPods and Bluetooth. The production value went down, but it opened what we could do in terms of the stories we were telling. We were dealing with a different set of logistics; where people were in the world didn't matter so much. Taking The Met outside of that physical footprint (and all those things that it communicates) let us break down those walls without even really thinking about it.

Digital access as a value statement

On online access platforms, Sofie says:

I think it's a value statement and we're putting a stake in the ground which says digital is worth our time and attention,

it's worth our resources, it's worth our effort, it has value even though it doesn't live within the traditional ecosystem people think of in museums. There was something about the meeting of that moment (digital and the pandemic) that has had a particular impact on how people view the value of digital.

Some of the things that are most onerous for people about coming to the museum are being able to navigate the experience, whether it's from a physical perspective, with access barriers, or whether there are intellectual, emotional, socioeconomic or inclusivity barriers with people feeling that 'I'm not supposed to be here' or 'I'm not sure don't know how to function here and I don't feel comfortable in this space'. I think museums are aware of those things, but in some cases they can be difficult to break down because there are certain architectural signals that are very difficult to overcome. But if you're saying to someone, 'I'm coming to you on your platform, like your phone or technology provider, and I'm going to do something fun and interesting with you here', that's a totally different way of connecting with audiences.

We move to Sarah's perspective. 'When I started working in museums, I was very interested in storytelling and almost reversing the way that museums approach storytelling, which was so object-first, and I felt like that was not the most engaging way,' she says. 'I wanted to tell stories that had characters and setting and beginning and middle and end. I ended up making content that was about putting people at the centre.'

In digital museum engagement, just because a museum can, that doesn't mean it should. The pandemic saw a rush of content to fill reduced in-person access. Digitization flourished, but not always in a positive way, with accusations of knee-jerk, poor-quality content or tokenism. How much content was useful or welcomed by the audiences?

'I think the ethical frameworks that we had established were one kind of radical accessibility, radical distributed content,' says Sofie, continuing:

> When I say radical, I mean not just putting it on our website and expecting people to come to us as we would expect people to come in through the doors of the building, but really saying the most important thing isn't to drive traffic to our website. The most important thing for our content was to be out there in the world on the channels and in the forums and in the spaces that our audiences need. That philosophical framework was important for meeting that moment.

So, post-lockdown, what does Sofie feel has changed?

> One change was the overhaul of our internal editorial approach where we created completely new [content rules], we created a new hub for all our content called Perspectives because it's not about truth and authority but about the multiplicity of voices that create knowledge and that ultimately create truth.

She continues:

You need to be a place that instils a sense of trust in the content and the storytelling that you're doing by having a certain set of expertise. The museum shouldn't want to hide its expertise, so that needs to be front and centre, but it is made more trustworthy and valid by being part of a conversation with other expertise and voices. I think there was a major shift happening during my tenure at The Met which was really examining – how is our content relevant? How are we creating multiplicity of voices? How are we thinking about how different stories and histories are connected and maybe can be in conversation with each other?

Sarah expands on this:

One of the hard things about digital media is that it's so invisible. Competition is very fierce because cultural organizations and museums are not playing by the same set of rules as entertainment and media. The work we do can be invisible or get so lost in that digital noise. You're asking people to decide to watch your content and hit 'play' before you've given them very much information about why they would want to. 'Why should I trust you with my time and my emotion?' I think that's one of the issues of the museum that is challenging, but also an opportunity.

Sarah muses on the application of digitization:

What do we lose in digital formats? The first thing that comes to mind is scale because it's very difficult to represent scale in an online collection. You can't really see it in space. The way that space and scale are used in

WHAT ARE MUSEUMS FOR?

hierarchies, and superiority or inferiority – that goes away in some cases through digital.

The Met Unframed is a useful example here – recreating some of the old masters on the walls in our own homes means we become the architect of our own museum space. It does not presume you've ever been in a physical museum before or seek to compare your museum experience with someone else's. It lasts as long as your interest, as opposed to a physical route you must sometimes complete to leave a museum. To not offer a digital platform therefore reinforces a lack of privilege, if the option is not there for us in the first place to visit on site.

Changing perceptions

The museum brand, even before you get to The Met brand, is curated, falsely treated as safe, family friendly, accessible, with no violent narratives and not overly challenging. That's the antithesis of what museum collections hold: they often have challenging narratives in plain sight. The Met online content hasn't shied away from that. Sarah says, 'It's important to have a conversation across media, places and communication channels about what's there and not there in the museum. Violence was a topic that came up many times for example. We have guns in the collection, knives, swords, instruments of war and colonization.'

Digital is a method for the institution to destabilize itself in perception of privilege; museums can create

storytelling remotely, with the storytellers themselves having the same access needs as the people they serve. As we encountered earlier, Met Stories' viewing statistics are incredible (five million views, 200,000 hours watched), but also speak of a deeper level of care, particularly in terms of social and emotional care when you access complicated/possibly painful narratives, such has those found in Met Stories. We know that museum stories are multi-layered within collections and that to have that conversation is to dwell possibly in pain, exclusion and anger as well as joy and inclusion. To put content out there that recognizes the duality of itself *is* ethical engagement.

Let's consider power dynamics here. Sofie says:

> Museums are really shifting the power dynamic and considering what are the important stories on care and considering an audience-first perspective. Instead of saying 'I'm going to teach you, I'm going to take you from A to B', I'm really interested in getting to those audiences which doesn't necessarily self-identify as museum audiences but are really interested in that idea of connection.

Linking back to the Met Stories 'Home' episode, it's useful to recognize that as digital access has the potential to enter both private and sacred spaces, this profound level of intimacy needs to be handled with care. Sofie continues:

> Museums have long considered themselves almost like temples – many of the buildings are modelled on actual

temples, and they have this air of authority around them – we assume validity in chosen things and how they are shared. The American model is founded on educating the public, a very altruistic motivation but one you are automatically supposed to respect. I think the notion that 'museums are for many people' is addressed in that episode. The proposition is 'What happens if we think of museums [dependent on our privilege] as our second home?' or 'What if we consider them as a space that we can project onto?'. We can fill in the blanks as activators of our imagination rather than other people's representations of ourselves.

As we reflect with Sofie on the episode of Met Stories central to our sharing, she comments:

I love it! I rewatched that episode with my youngest kid just the other day and she was completely fascinated by that detail. The production team working on this were incredible and we really focused on that idea that these lived experiences and stories were much more important than trying to get across a detail that was significant about the work. And that's probably one of the things I'm most proud about in this series. Emotional moments in it are as important, if not more important in our storytelling, than trying to get across that the detail is about Rococo art, which is utterly irrelevant to some people. I hope it begins a process of discovery (which could include appreciating the artistry of 'home') and that can happen anywhere in the world via video, and because The Met itself is of the world.

Digital museum approaches entwine with the physical approach, meaning that on a deeper level (economically, socially or transgenerational) our sense of belonging changes. Sites that for some are violent histories can be accessed on their terms. Museum collections shake off the 'cuddly and safe' default version and apply questioning to these spaces. With this comes consideration of what should and can be digitized.

Sofie reflects:

> In terms of working with particularly sensitive audiences, where you're really creating targeted experiences for them, you are engaging in a contract of trust and care in a very different way than more of the general content (which may also of course have its own harmful side effects). Particularly when you are thinking about more vulnerable populations, I think it is important to ask that question of 'Why are we telling these stories?' to begin with. Do we have the right frameworks in place? Do we have the right processes in place? Are we going to be able to work with these audiences in a way where we are not assuming that we can represent their needs or views? One of the most important considerations is not assuming that I can understand and speak for all of the audiences that I'm creating for.

There is a powerful duality in terms of access – absolutely, museums should be telling these stories; however, the institutions have also been arguably complicit historically in so many forms of censorship. Can museums use their privilege transparently for others? Sofie responds:

I do think that there is a level of vulnerability where if you are putting content out on the internet. You are not able to have some of those direct connections and feedback like an in-person experience. A teaching programme is going to look and feel very different from a digital program. But I do think there is a rigour to the digital production and editorial process which is also helpful- with the right kind of intent and with the right framing, which maybe demands more of the content. My hope for museums is that there is a willingness to be brave and to take risks, make some mistakes along the way. I think the best we can do is to continue to learn and to look for outside partners and collaborators.

Digital futurism in museums continues to evolve and reach further into society. Platforms rise and fall, apps are downloaded and deleted, passwords get lost. You can go viral with a clip, and then have little to no interaction. Digital platforms are designed to expire, shift and become something new. Can museum content keep pace? Sofie says:

The future of museums lies in being able to both seek relevance and keep an eye on the things that sustain us. Seeing digital platforms less as individual solutions and more as part of the whole storytelling ecosystem of the museum. The challenge of museums is that a very small percentage of collections are typically on view at any given time. What are the gateways that we're building into that content so that audiences can connect with them and even be a part of determining their value?

We need to be creating pathways to connections rather than be gatekeepers.

Sarah comments that, because of the size of The Met's brand footprint:

anything The Met does is going to get good numbers comparatively. So, one of the things that we looked at in measuring like Met Stories' success was the comments. We didn't do any kind of formal analysis of those comments but followed their story. On top of numbers, there is a tier of cultivating belonging. That sense of exchange of identity really is what we're after. You belong here with us and we're part of you as well.

What are museums for?

Sofie offers:

To see where we've come from, where we are now, and where we're going. Museums need to address all of these aspects to be vital and to speak to each generation. And to remind people that most are also sources of joy and pleasure, right? Spending time with each other or even creating art. But I think in this next iteration, they are also places for civic dialogue, activating and making social change. They are expected to have an impact on our communities and to engage with social issues beyond our historical or artistic remits. That is something each institution must consider: how to be true to the individual mission of the institution and

how the contemporary issues of our day relate to their specific communities.

It might mean asking 'What does it mean to look at history from our contemporary perspective?' We have agency in a way that no other audiences to date have – we have incredible access to information. I think museums are fundamentally places where we can have time to investigate and understand ourselves as human beings. They can truly be places of transformation. Transformation can be small or huge. It doesn't necessarily happen on site. It doesn't necessarily happen in the moment. But maybe a week, year or ten years down the line, that encounter has had some kind of impact in how you relate to others.

Sarah suggests: 'On our very best day, museums are about building empathy, capacity and perspective. Challenging assumptions, garnering a sense of belonging and community and reflecting the human experience.'

Museums offer the possible combination of slow learning, solace, finding ourselves, and commonality with people that we care for and care with. Simultaneously, space to hold opposition. Space to make small incremental moments and changes in our lives, whether that be comfort, care, togetherness, or as we saw in Met Stories, profound realization in terms of voice and self – those are small moments that incrementally build into something much larger.

Met Stories and The Met Unframed do not attempt to recreate the museum as it stands. They don't necessarily offer the augmented version. They offer something that stands alone. Digital media is not perfect; no access

route to museums can be. They are still mitigated and regulated by a default level of control, tech requirement and economy. Yet value and intent must be recognized. Perhaps that's what museums are for: creation on *our* terms, using a wide range of tools, rather than recreation for a privileged few on site.

5

THE MUSEUM AND TRUST

Leninists, terrorists, feminists, gay liberation activists,
human rights lawyers, celebrities and conformers – these
are the familiar figurers in the stories that are told of what
happened after '68 had ended. For them, the global
revolt was part of a longer narrative. But there are others
who could not so easily put the events of '68 behind
them. They had briefly been freed from everyday life and
given a glimpse of world in which the impossible could be
made possible.[1]

Trust is not a given in museums; it's earned through
trustworthy actions. Museum storytelling is never
neutral and often occupies spaces characterized by
intersectionality and plurality, and links directly
to national and international law. Just as people's
identities are intersectional, so too are our histories
– multiple readings and viewpoints co-exist and need
to be acknowledged. Museums need to equip others
with the tools to make their own minds up, rather than

claiming intellectual dominance. Should that act of equipping others be a museum's function and mission? The museum in the global West has presented itself as the ultimate source of empirical answers. Where do museums stand today regarding this tension between empowering personal exploration and providing 'an answer' for, rather than with, us?

National Museums NI (in Northern Ireland) have a powerful example of a collection holding rich, potentially painful and politically sensitive history. How can a museum tell such a story? What role does trust play, and how can it be earned? Using an emotive piece in the collection which speaks directly on the Troubles, this chapter explores the power of trust when sharing history with others.

A quiet witness to history

The odds of this 1960s television set having survived are slim. It's old but not of antiquity, damaged, unremarkable visually and, at first glance, unexpected in a museum. Yet it's found a home in National Museums of NI and holds a powerful place in an exhibition called 'The Troubles and Beyond'. Together with an incredible archival image from 1969 of this object's history, the television bears witness to the escalation of communal violence in summer 1969. In July and August, ten people were killed, 154 shot and wounded, and 300 treated for the effects of CS gas. Many houses were destroyed, including almost all of Bombay Street. In Belfast alone, 1,820 families fled

Figure 5.1: Television set from Bombay Street, Belfast, 1969

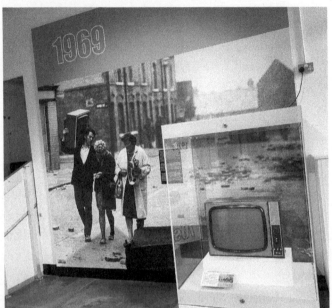

The same television can be seen in the graphic behind it being carried by a member of the Hemsworth family in the aftermath of the burning of Bombay Street in 1969.

their homes, and 'peace walls' were erected, separating Catholic and Protestant neighbourhoods.

'The Troubles' describes three decades of conflict in Northern Irish history from the 1960s to 1998, when the Belfast Agreement, also known as the Good Friday Agreement, created a new power-sharing arrangement. This major moment in history saw a significant development in the Northern Irish peace process, multi-party power-sharing, and a de-escalation of multi-generational violence in which more than

three-and-a-half thousand people lost their lives. Its impact cannot be overstated within global politics, and more significantly within the multitude of communities who lived through this time.

The television set seen here alongside an archival photograph is the one carried by the Hemsworth family in the aftermath of the burning of Bombay Street in August 1969. Captured in a moment of incredible poignancy, we see the television set carried through the rubble, a fleeting moment where this piece intersected with visual human distress. Its survival depended on the family retaining it in a new home and garage, quietly eroding and unused until its donation to the museum generations later. That act speaks of trust – understanding that the television operates in synergy with the photograph, considering the museum to be of status, and believing that museums have the power to change lives. To trust a museum with both the ownership and responsibility of sharing the television's story is remarkable.

Museums have the power to elevate and amplify lived experience. But how do those both with and without the lived experience of this historical event access the story? Massive and detailed narratives, dates, testimony and legacy can often be a daunting challenge in accessing the past. Where do we start, and more fundamentally, where is our human connection to such narratives? Perhaps the key lies in pieces such as the television.

To see this object is to be with a passive yet relatable witness to history; its ordinariness is part of a domestic narrative most of us can connect to. Where geography,

identity and politics may divide us, the television set is a familiar reminder of the domestic. Few experienced the reality of Bombay Street in 1969, yet all of us arguably are connected to Northern Ireland via international politics – global citizenship alters our daily reality, politics, laws and media, whether we are aware of it or not. The television set becomes emblematic of a moment of emotion at the scene – a conduit for empathy and shared connection to an event some may struggle to process or comprehend. Why save the TV set at all? What is its significance? To ask is to begin to invest yourself emotionally.

Think for a minute about experiencing mounting violence where you live. What would you save from home if you had to flee? Would you even be thinking practically, or are you acting on instinct? For many in working-class communities, the television was a prized object. At this time, people frequently rented their television or bought it under a hire-purchase agreement – if you've not finished paying it off, the TV's not even yours to lose. Go deeper to the significance of the TV, particularly for working-class communities. Televisions in the 1960s were sometimes communal and shared, prized for vivid, up-to-date information that other media could not offer. Add the extra layer that in Northern Ireland, public broadcasts included updates on the Troubles and possible violence, and therefore access to news became a necessity. Its multiplicity of status (entertainment and link to civic life) elicits keen emotion – the left-hand figure both carries the television and simultaneously comforts another person.

A question of trust

There's an inherent social agenda in the act of museum display. Museums exist to codify and categorize, and by their very nature objectify the lived experience of others. There is a perception of default conservatism, risk aversion, perceived safety and ultimately of freely given trust. Yet the reality of our museum collections is anything but that; they are rife with simultaneously dangerous and potentially beautiful opportunities.

To not see yourself in a museum implies that your life and lived experience is inconsequential or of lesser value. We, as museum visitors, are stakeholders. In public collections, we sometimes own these pieces communally as citizens and voters. One of the central provocations of this book is that collections need communities more than communities need collections. If what museums display is not representative, communities without a connection will find their own solutions. They will find their own heritage, their own answers, and they will make new heritage. It's for museums to demonstrate their value and show that collections have a place in terms of advocacy.

Trust in a museum by those it represents is the vital link – earning, deserving and retaining trust that the stories they tell are representative, made with, not for, others. We pick up this conversation with two expert colleagues from National Museums NI, Dr Karen Logan (she/her), Senior Curator of History, and Hannah Crowdy (she/her), Head of Curatorial. Both were interviewed in person, responding to each other and the author in a quiet museum office bathed in sunlight.

One powerful phrase used within interpretation displays at National Museums NI that leaps out visually is that while we have shared history, we don't have a shared memory of that history. Hannah begins by reflecting on National Museums NI's relationship with trust:

> We are thinking much more about what we have done, and we haven't done. It's really timely asking these questions because the museum is marking its fiftieth anniversary. There's been a museum on this site before that point, but this form opened in 1972, the worst year of the Troubles in terms of loss of life. So, we've been trying to examine what the museum meant to others. It was a very bleak, dangerous situation here. The museum offered a kind of escape in discovery, something that was more positive and brighter about life that wasn't divided.

Karen reflects on applied museum practice:

> I think we as a sector have been doing a lot of soul-searching. Museums must change. With digital engagement, for example, we're going to be in the visitor's home. It's about trying to help people find themselves and building a community is a big part of it. If people see themselves represented, they begin to let themselves be open to other points of view. Multiple community perspectives together are so important, and that people find themselves within that.

Karen sees the pandemic as having accelerated change:

That's also connected to trust. I think the pandemic has brought us to a point where the museum has got a strategy – it's exciting, living, breathing and ambitious, connected with society, what we want to do and how we want to be better as an organization. I suppose in the pandemic crisis of identity, when you suddenly can't visit, museums must ask visitors, do we have a purpose? The most important thing is that we justify our existence.

Hannah continues reflection on future learning and adaptation:

It's not just saying that museums will act; it's asking what difference is this making and how can we measure that? There's a beautiful shift of engagement in terms of the co-generation model where, historically, sharing with museums meant that the outcomes are rigid. Instead, by being in the collection, *they are us* [as an institution].

Deserving trust

Do museums deserve our trust? More importantly, do they recognize it's something we as audiences give as a gift? Hannah suggests:

For us, it's by being courageous that we've got where we are. For a long time, this museum certainly wasn't courageous. If we look at how the museum dealt with the Troubles period in exhibitions, this museum was very 'safe', very 'bland' and had no objects. It was just a huge disappointment to people; they didn't feel it reflected their experience.

Hannah continues:

> The museum couldn't quite think how to deal with the
> Troubles. They were obviously very close to the Good
> Friday Agreement, and we are now at more distance.
> There was a lot of anxiety about it. What we've done since
> that time is to make sure we evaluate, talk to audiences,
> try and get a big picture of what's working. In around
> 2014, we started that process. I think it's one way we've
> got here, and just being that bit braver, learning as we go,
> has increased our competence. I think the other thing that
> we've done, which museums never used to ask, 'What is
> missing around museums?'

Learning as they go manifests in action – asking
what steps to take with others, changing approaches,
techniques in the museum, text, displays, the tone
of how they communicate and on a financial level
the choices they make in funding change. A process
that recognizes failure within museum practice is
vital, inevitable and, when used for growth, useful.
Karen says:

> Definitely it's that kind of openness, accepting we don't
> have all the answers and we're not always going to get it
> right. Certainly, it's holding onto this desire to be trusted,
> and for our roles in museums to line up to that. We're in
> the position that we've learned these lessons – what is
> our next step? How will it be done? One way that we
> really got that right was by viewing it as a process. We
> were open with people, and at the first stage did a call

for people to get involved, come forward with objects
and stories. It was about the reflection of the citizens and
their position.

Outreach to communities and partners becomes a series
of attempts to be trustworthy and by which to judge
and hold the museum to account. This exhibition in
profile developed from the photojournalist approach
to one of intervention and conversation. Hannah says,
'You start with an empirical place, recognizing that's
not where you're going to end up. The gallery asks,
"What do you feel is missing?"'

The National Museums NI Organisational Values
and Ethics Policy explicitly talks about being brave,
compassionate, exploring the concept of bravery,
knowing that it will alter the institution and those
within as practitioners, coupled with compassion.
That's tangible in considering how museums earn and
deserve trust. Bravery is not considered an automatic
state in museums. Bravery is vulnerability, something
not historically associated with elite cultural spaces.
Within that is humanity and commonality. Hannah
offers a powerful example:

That's one of the reasons we deliberately chose to add the
punk outfit to their exhibition. It's the first thing most people see
when they go to the gallery, and it sets a tone of challenging
expectation. This isn't just going to be a space about conflict
and confrontation. This isn't the only story of what life was like
[during the Troubles]. It's an image of the time.

What are museums for?

Museum collections are varied and powerful – remarkable encounters such as political banners, weapons and bomb-defusing technology from conflict can exist alongside what some may see as mundane in comparison. One story from National Museums NI that illustrates how special trust can be when earned was the temporary loan of a small but monumentally significant object, a chocolate bar. Found in the clothing of a relative killed during Bloody Sunday (30 January 1972, in Derry), the piece of confectionery was treasured and preserved as a vivid personal link with a lost loved one, kept in a bedroom drawer for decades. Exhibited in The Troubles and Beyond gallery for the fiftieth anniversary of Bloody Sunday (January 2022), it formed part of a detailed narrative on sharing the Troubles from multiple perspectives. To honour this loan, the museum itself had to change – strong museum lighting, for example, could damage the chocolate bar so new display solutions had to be devised. As with the TV set, it's a remarkable manifestation of trust. To leave the home, its safety and intimacy, for a public setting is an act of immense trust.

Hannah suggests that trust is always in everything they do:

> It's tested regularly as we still have a huge amount of work to do. There's a lot of people that might not necessarily trust the museum. There is a problem associated with the building and the very physical presence of the museum. It's imposing. Also, the fact that we are called National

Museums NI and I know some people here therefore
recognize the museum as representing the state. It's
important to show people how we work as it gives them
more confidence in what we're doing: that we're honest,
that we have a level of humility in what we're doing, that
we are transparent. I think that helps build trust.

Karen underscores the importance of 'being
respectful, being clear that you respect and value
people's contributions'.

Critical friends' networks (external independent
voices from others in the wider sector who challenge
practice and hold to account actions in productive
critique) are also a powerful expression of trust.
As Hannah explains, 'The critical friends is a really
interesting point for us because we are translating our
critics into critical friends, and they're really the most
useful critical friends.'

Hannah sees the museum as being in a state of:

evolution in how we fulfil our original opportunity, and
I think that's one of the things that ties into trust. I think
people see our starting point, and they see where we are
there. There's a fossilized view of us in terms of that colonial
heritage that's not good. Whereas we are very gradually in
progression. I think I changed a lot, I've learned a lot, my
views and opinions have developed over that time, and I
will continue to, as I continue to work with them. That's one
of the real privileges. It is a very natural evolution, and they
can happen quite gradually over time, but on something
like decolonization, it's such a fast-moving debate.

Museum visitors see a version of you six months ago, ten years ago, as it was displayed.

Karen shifts our conversation into the goals of museum engagement:

When people ask me what I'm trying to achieve, in that exhibition, my focus is that people leave with a greater understanding, and a greater appreciation of the effect today. What we thought as we came in the door is not just as simple and clear-cut. People will be that bit more critical, their interpretation will be of more perspectives, understanding that the Troubles is more complicated than they might have thought when they walked in.

Hannah adds, 'I encourage you [the audience] to do this. I try to just sit back, absorb, and try and understand.'

Let's return to our piece in focus, the television set that belonged to the Hemsworth family and the burning of Bombay Street in 1969. It had been kept by the couple's daughter, whose husband now works at National Museums NI. Jane McWilliams, a granddaughter of the couple, has made a short documentary about the impact and legacy of their experiences as part of her Broadcast Production degree at Queen's University Belfast. National Museums NI have made this available on their website. It's entitled 'What You Have to Remember' and concludes with a quote from her grandmother: 'Your name will go further than your feet ever will.'

Figure 5.2: Television set (detail)

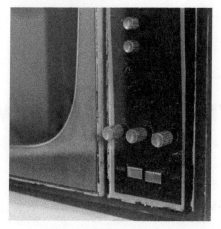

Perhaps that's what museums are for – to carry our stories further than we ever could. That's why it's vital they win our trust.

6

THE QUEER MUSEUM

Figure 6.1: Matt Smith, *Happy Union*, 2010

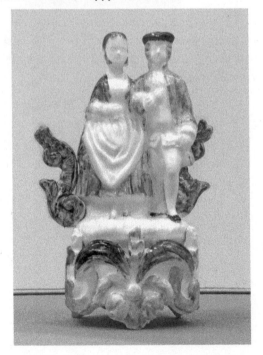

Once the performative force of queer is taken on with pride and insubordination, the veneer of enforced normalcy cracks. Sites of resistance, resilience, dissent, and immoderation appear everywhere as possibilities of rebellion, for connection and for solidarity. Queer artists are exemplary at this. They see the experience of difference and dissent as replete with capacity and make visible the otherwise as a means of valuing it.[1]

Museums have gaps in how they tell our stories – we might presume they are universal records that include everyone. In reality, the storyteller decides what to emphasize, who and how. As communities increasingly use museum spaces to tell their own stories in their own terms, these gaps can be positive spaces for creativity and activism. LGBTQ+ (shared here using 'Q' ['Queer'] to represent the broad intersection between identities) narratives and representation in museums offer a rich source of dialogue. The mere presentation of museum objects is never enough; institutions must recognize that labelling alone cannot explain an unspoken feeling, such as queerness. Other processes of imparting information about a museum object, such as documentation and staff working methodology, should also be critiqued. Representation matters. Can museums help achieve this? In the past, queer history has been systematically overlooked, misrepresented, erased, destroyed or reinterpreted. How can that past absence be addressed in museum collections today?

Power in Porcelain

Happy Union by Matt Smith, 2010, is an artwork offering a really important conversation on inclusion within its tiny scale, seen in 2023 at the Walker Art Gallery in Liverpool UK (within its own case surrounded by the Pre-Raphaelite collection). Two figures linked together face us with an old-world chintzy, kitsch enthusiasm, visually referencing eighteenth-century domesticity and charm. One in a dress, one in trousers, our porcelain couple are ageless in a peculiarly British aesthetic – often repeated in art across time. They are pretty, ornate, and would be equally at home in a museum collection or on a working-class mantlepiece, perhaps decorating a pub interior. A relatable grandeur, something your grandma would treasure, perhaps. Reassuringly domestic, our couple seem to blend into history and pop culture.

Yet there is a potential realization that rewards your effort in seeking its truth – while you might assume a male and female couple based on their clothing, both figures are male-presenting, with facial hair. Look once quickly and you may miss this, a museum piece which pulls on assumptions in the first reading – it must be a man and woman; the artwork looks to be from the past where queerness wasn't shown? A Victorian-looking museum would never have queer people on show surely? Yet pause a moment and absorb what's here – two male-presenting figures and an artwork reflecting marriage equality in the UK in 2013 legalizing same-sex civil partnerships.

For the UK this is still recent – a fascinating moment captured in contemporary art that rests on the achievement of equality. Peel away the visual delivery of comfort and presumed unproblematic aesthetic, and we find a piece of art which calls to us in terms of social justice. It speaks to a deep inequality; generations of queer people in the UK have grown up with fewer legal rights than others, whether that be the right to marry or the age of consent. There is deep self-awareness in this artwork made by a queer artist of the power dynamic of queer communities having to justify themselves to the mainstream and find/hold space in museum settings.

This artwork rewards your time and effort with radiating emotion. To empathize with this story is to challenge what's historically normative in a museum space. 'Happy Union' is often talking directly to queer people about queer people, coded visually in camp, for example. It's cheeky, has humour, is self-aware, does not shy away from pain, and ultimately is empowering. It asks the viewer to recognize queer people's democratic, emotional and financial value in museums. It creates space for the often-erased queer life that sometimes isn't attainable without lived experience. The museum piece is a constant in the collection that cannot be opted out of, a piece of shared history. You may feel its 'otherness' before you comprehend it – some might find a coded message reaching out to others for exploration.

Consider the sensory aspect to Matt Smith's work in clay and ceramics – he fashioned the artwork's final

form much in the same way that we are shaped by the society that we find ourselves in. There is an element of the audience and artist combined taking control of the museum space here, coupled with a deep humanity. Reactions witnessed to *Happy Union* vary – it can provoke a sense of solace, joy, reflection ... all achieved through the incredible generosity that Smith puts into his work.

Queer communities are one voice within many that have been marginalized historically by museums and the societies that created them. Our identities sit at many intersections and common struggles. While the different experiences are not comparable or conflated here, queerness and the process of sharing queer history in museums is one perspective through which we can consider museum functionality – not by what they contain but by what was erased. Queering rests in the act of revision, reinterpretation and more fundamentally using lived experience to share stories. These are not additions to the museum; they have always been there – in plain sight, yet often with little to no recognition of their value. Revising this values system is an empowering conversation on museums and inclusion.

Let's explore this piece and the conversation it provokes with three experts: Artist and Curator Matt Smith (he/him); Head of the Walker Art Gallery (part of National Museums Liverpool; NML), Charlotte Keenan (she/her); and Dan Vo (he/him), former Head of Learning at Queer Britain and founder of the V&A (Victoria and Albert) Museum queer tours. Each was interviewed separately – Dan and Matt online over

a virtual cup of tea, and Charlotte at the Walker Art Gallery in an office packed with a dizzying array of art history books.

What do we expect historically from museums?

Matt says:

> Museums are 'establishment' – not all of them, but nearly all of them – and they come out of a legacy of what the status quo was in terms of colonialism, a discourse of classism and ableism. Queerness and queering for me link to sexuality, but it's in no way constrained by sexuality. That's what really excited me about queering the museum – it's a destabilization rather than just queering the organization. I think so many curators are aware of the legacy that they bring, that the museum brings with them, but I think it's very hard to be in one and turn it around. It's not impossible, but I think when I worked in the museums, I found it a lot harder to put that mirror up publicly in my role than I do as an artist.

Matt continues:

> I'm more interested in whether museums are telling me stories I wanted to hear, not if the current narrative is good or bad – is it boring, or is it going to challenge me and engage me and make me think differently? I think a lot of them were set up with a very paternalistic 'we will educate' and that is on one level a very kind thing to share with someone. I think there's the perception that museums have never been as nuanced as they need to be.

Museums can be used for activism, but historically haven't been associated with it. So, is the use of our personal agency welcomed in museum spaces? Charlotte explores this within her own practice:

> Coming from a very working-class background I didn't visit museums and galleries as a kid, I didn't go into an art gallery until I was about seventeen. I was drawn to these architectural spaces. I really looked up to museums and galleries, saw them as these places that housed history. I really liked the interpretation because it told me what to think. I wanted to know enough to write those labels. Now I'm the opposite. I don't want to write the labels – I want other people outside the institution to write the labels. I think that tells you a lot about the journey that I've been on, and, to some extent, the sector. The perception of museums as gatekeepers to history was something to be revered. Now I try to critique the institution from within and work with incredible colleagues and constituents to question those assumptions of what a museum is.

This drives forward our conversation – what happens when we articulate that museum institutions are not immutable? Our footprint within them is transitory, yet we can have agency. The practice of queering is a tangible manifestation – it enables museums to articulate that objects are tools in communication.

Dan points out that his generation grew up in a much more anti-LGBTQ+ society, and that included the museums:

I come back to that idea of who was permissible in museums because we were not given permission to in my generation. I think some people need to root themselves in a sense of realness, because our truths are not the truths of the person standing next to us. We need to root it in a shared history, but not a shared perception of that history – that's very important.

Meta-narratives are the huge stories that bind us all, parts of life we all share, such as the environment, for example. Seeing marginalized voices included within these stories is a way to explore equality and opportunity. It's a method of operating and interacting with both our own identity and each other. People need meta-narratives to be understood, rather than prove they are part of meta-narratives in the first place. Holding that space of understanding is an essential level of equity in museum spaces. A testament to the power of museums comes in the form that even within a history of negativity, people can still find queer joy in museum spaces. As Dan reminds us, 'Queer communities very clearly care about museums, otherwise they wouldn't keep turning up, they wouldn't keep donating, they wouldn't keep engaging.'

To be political

When we consider the museum as a reflection of history, we must question whose history we see. Matt says: 'I'm not sure that museums are democratic spaces. Some voices get heard much more loudly than others.

Who, for example, has the labelling machine? Who gets to choose objects? It's not democratic at all. Which objects are selected? Where does money go? These are not particularly democratic decisions.'

Museums are inherently and inevitably politicized. Curation is therefore also inherently politicized. Here, though, lies the power of recognizing queerness in collections: it holds space. Matt continues:

Taking queer identity as an example – that in the last 150 years, being queer was something you did, it wasn't who you were then. Now we're getting to a place where it's not that big a deal. I think one of the big issues with museums is that they can try and generalize or come out with blanket statements but the world's more complicated than that. There are thousands of queer narratives within all museums, and they have been actively airbrushed – that didn't happen accidentally. Historically, queer identities were only recorded by the state through either criminal or medical records, historical evidence is in short supply. When you then discuss known queer people in history but do not mention their queerness, you're working very actively to erase queerness. I think as a visitor it can make you feel as though queerness is unacceptable to the mainstream, that we are transgressive morally.

For me the big shift with queer rights and ability to exist was the abolition of Section 28 [UK law in effect from 1988 to 2000 which prohibited the 'promotion of homosexuality' in schools]. That scar was, I think, a really comfy way of museums (and any public sector organization) just avoiding any reference to queerness.

Dealing with any identity group that isn't usually included in the discussion, it's always difficult, and I think Section 28 gave people a real get-out to not even need to try. I do think with civil partnerships that repeated exposure that people outside of the queer community have of seeing two queer people committing to each other as mainstreamed is beneficial for queer visibility overall.

Functionality and museum activism

'Generous' or 'benevolent' intent by museums can and sometimes will be seen as toxic. Matt shares:

One of the most awful manifestations of the museum I can think of is that idea 'we can help you with your identity' coupled with a history of queer erasure. Whether people intend or not, it implies 'you come back into the fold' or 'if we can package you in a way that we can understand you, we can show that'.

A powerful consideration on the need for museums by queer communities. Without museums or need of museums or gallery spaces, queer people will create their own visual solutions and material culture. Queer people generate their own heritage solutions because public spaces have historically been denied. The act therefore of holding space publicly rests in both activism and change.

Dan reflects on an example of activism – setting up the V&A's queer tours originally as part of the museum's Friday late queer-themed events.

It's just inherent in the programme now, so you don't need
to declare this is the queer one. You know, there's pros
and cons to that but, for me, it felt radical in 2015 to do
these tours. Soon we had a queue, so we put more of them
in the programme. It felt like it was revolutionary, even
though it wasn't. It feels like the sector has always been
driven by some people who go, 'We need to do this!' –
we've always had these acts of resistance in museums. The
programming is the easiest thing to do. It's the intellectual
engagement that's harder and this will change over time.

The LGBTQ+ experience is not linear and it's not one
experience, therefore queering in museums must allow
for complexity, change and experimentation. Change
manifests in both large and small ways. At NML,
for example, it came in the form of custom-made
mannequins needed in a queer exhibition on cross-
dressing and queer expression. Here, the collection
displayed the acquisition of an extensive (and hitherto
unknown) collection of ornate Edwardian-inspired
female-presenting clothing from a Liverpool resident
called Peter Farrer. Titled *Transformation: One Man's
Cross-Dressing Wardrobe*, this show ran from 2016
to 2017.

Charlotte tells us more about the project on
Peter's wardrobe:

Importantly, we represented Peter's clothes in a way that
was true to them and started a conversation around cross-
dressing, gender presentation, lived experience and body
dysphoria. I think that was a project that could have been

really complicated and some galleries might have avoided doing it. The clothing was very ornate, a lot of crinolines, a lot of lace, including bespoke pieces Peter wore and vintage gowns he collected. There was something very specific going on there linked to his enjoyment of wearing these dresses, a fetish, but also linked to our understanding of gender. We had a fantastic response to the show because actually first and foremost a lot of people just recognized these dresses as wonderful – really gob-smacking – pieces – as well as an exploration of identity and self.

The exhibition was ground-breaking, not just for the Walker and Liverpool in terms of content, but also in what audiences can expect from an exhibition. Matt reflects on holding space in museums:

I think partly museums were always somewhere I went to as a space I felt okay to exist in, so in some ways it's a selfishness to my arts practice of 'actually I feel safe here to a point and I want to just push that and see if it is truly safe'. You're testing the nature of the relationship. There's also a real sense of doing the work with the museum to ask, 'Am I welcome?'; I'm going to go around the museum and just see how many times you mention LGBTQ identity and feed that back to you.

Audiences can and often do reflect on damage done in the past in museums. Art such as *Happy Union* creates new history. The pain of erasure and a lack of representation can be honoured but can also be a joyous moment to find ourselves in museums. Gaps in

collections are places in which we are not suffocated by the potential emotional toxicity of what came before; we can populate that space with contemporary identity: for example, in terms of the recognition of non-binary identities, gender non-conforming dialogue and fluidity.

Finding queerness

Queerness (as with many other identities) manifests itself not just in evidence-based research – it's also a feeling, an aesthetic and emotional encounter. Museums often look for analytics or statements of fact. However, to find that in identities with legacies of erasure and illegality is often impossible. What therefore is the intangible feeling of queerness in a museum collection or building?

'I think we will all find queerness in different places,' says Matt. He continues:

> Often, it's a feeling. Queerness requires consent and people deny that queerness exists in the first place. I think it also takes confidence and I understand why some well-meaning people might not think it's their story to tell. However, feeling it's not a story to tell can be read as an erasure, a silent thing, and an uncomfortable mess. Feeding back with genuine compassion to the museum shows its unwitting effect.

Queerness often doesn't line up with established ways of curating, requiring institutional change. Dan

reflects on searching queer collections, neutrality and asking questions:

> Have you thought about how you might be misgendering or misrepresenting people? Or how searchable a museum collection is? How do you start to ask questions? People within and outside of museums have always argued that museums are not neutral, so how do we advocate for the side of social justice?

Matt continues by offering on his experience of queering collections:

> I can't rely on what somebody did with these objects before and to do it well requires a huge amount of thought and care and consideration, which I'm delighted to do, but it slows stuff down. The pace of queering is radically different, I would suggest. In my practice you have a shared experience with a community and a position, balanced with the authoritative position of an institution that carries so much power and influence.

Dan amplifies this:

> Queering is emotional. One of the big tenets of queer futurism is, if we are able as a society to get to a point where we're not self-justifying our own existence, what could we do with that emotional oxygen? And I think the queering process is taken up on the perception of self, orientation of self, and making sure that we are safe within those spaces. Queering is a process to say, you belong. You are accepted, you are celebrated.

Charlotte generously offers on her own journey within museums, from young visitor to working curator exploring LGBTQ+ identity:

> Early in my career I had a realization that there was far more to museums than was being presented. There are a lot of people really invested in protecting the traditional idea of museums as gatekeepers of unmovable knowledge and culture, but I think we need to acknowledge that knowledge changes. It shifts. It's slippery. It's not a constant, it's not something solid. For example, we have object history files for every artwork in our collection. In them, we can see shifts in understanding, in relevance, in interest, in value, both financial and cultural over that time.

Queer futurism in museums

Trust in the continuation of active queerness is vital – will this opportunity end? Do we trust in museums, that there are going to be further opportunities in the future?

A moment of vulnerability perhaps for communities that have not invested themselves in museums before. The danger here is that without trust, we may put too much into current activism, not believing there will be opportunities for future activism. Is the process of queering inherently positive? One legacy of queering may be anger and loneliness, a resurfacing or triggering of inherited community or personal pain. LGBTQ+ community co-production needs the space for both positivity and negativity.

Matt gives us an example of emotion:

> I think it's deeply traumatic, bruising, to go into exhibitions
> that contain queer people, but they will not talk about that
> queerness. An active message that being queer is not okay
> is sent. I think for me museums generally are quite queer
> spaces. They're all about objects that you're not allowed to
> touch. I find it quite interesting; we perform in museums in
> a way that we seldom perform in other spaces. They allow
> me a time for queerness and reflection. I think if a gallery
> doesn't feel queer, then I haven't looked hard enough.

Language is a key tool here, and with it the consideration
of who feels and/or who can use reclaimed terms.
'Queer', for example, as a term is both painful for
some and joyous for others. Dan considers applied
language in museums:

> I love the word 'queer', but I think it can sometimes be a
> word that people hide behind where they don't understand
> the community. It's not a lack of intent or morality or desire
> for inclusion. I think because we represent such a small
> proportion of the workforce, there needs to be a literacy
> in terms of how to express us, how to access us and
> how to articulate us, especially when we're not part of
> the conversation.
>
> We still need to say to queer people, 'You are welcome
> here. Your story is belonging, and your story is a part of
> the entire fabric of this institution.' Right now, 'queer' is a
> beautiful word to use to describe it, but we might come up
> with a brand-new word that will be a better umbrella.

Charlotte continues here on the theme of museums changing:

It's been important for me to throw the idea of a linear narrative out of the window and embrace a multiplicity of narratives that coincide, that contradict, but co-exist, celebrating a multiplicity of meanings and histories. I think in line with that, my approach to collecting for the institution, to increase the representation of queerness in our displays, has shifted away from this quite straight, linear approach to identities and history towards instead providing opportunities for queerness within the collection. Spaces where artworks are a catalyst for reflection and conversations around sexuality, gender, identity and queerness. Perhaps we can reconceive the museum as a place that asks questions rather than offers answers.

Matt reflects:

I think part of queer futurism is us realizing that the curatorial rules don't always apply, and it's as legitimate to not use those rules because those rules erase us. It's tough because we've grown up thinking we need to reference stuff, or we need secondary sources to validate. Yet we are working in an area where criminalization, invisibility, erasure, medicalization mean that the records were burned unless you were super-wealthy (and even then, society would stop you leaving a legacy that would allow us the same privilege to information as it does for other parts of society).

Our piece in spotlight is a powerful example. In the dominant heteronormative expectation and competing moral, ethical, and religious values that shape museum collections, we find a bridge between the past and present, an ally in representation. Ultimately, we recognize that museums aren't history. These are spaces that change over time, and where people will come to tell their histories.

What are museums for?

Matt offers:

> The heart of museums for me is material culture. I'm not saying museums are for objects, but I do think this has to include in a discussion. I strongly believe museums are there to reflect the communities. I think they are there to be a safe space for everyone. I think they are there to allow healthy and respectful debate. I think they are there to allow a safe space for challenging each other. I think they are there for us to learn about each other and ourselves.

Dan says:

> I think we've all been worried about whether we can cross that museum threshold. People are worried about the sense of entitlement. So, when they cross that threshold, there is a feeling that you made it. This is you. What are museums for? It's the possibility of being able to connect with people on this incredibly personal, heartfelt and transformative way. It creates that possibility of relationship. I think it's

always those unexpected moments that are the best ones, are when people see themselves in the collection. Then suddenly, a little crowd of people just gather around because of that sudden shift of the voice of authority.

Charlotte offers:

For me, the future is reimagining all our galleries to be queer museums, queer spaces, but also women's history museums and Black history museums and disability history museums. That we understand these histories as central to the collections and stories we tell in museums all year round, day to day. I think where I'm at right now with my practice is very practical. It is about working to create expectation within the institution that we acknowledge queerness in all that we do, because it is always there. A strategic approach that, eventually, becomes embedded naturally into everything that we do.

The museum as 'other' is an opportunity for us to transform ourselves into our own heroes within those spaces. Perhaps the counterbalance to the structure that denied queer people is the same vehicle that can uplift them again. People are not necessarily seeking elite historical voices; they are seeking to be surrounded by new voices. Perhaps that's what the museum is for, a way to *hear* those around us.

7

THE CHANGING MUSEUM

We cannot confront another person's head without
sharing an understanding: face to face we are peering
at ourselves. We are hard-wired to react to a person's
facial expression, spontaneously and unconsciously. We
experience an automatic and rapid neurological response
to seeing a sad, happy, angry, or distressed face which
causes us, unconsciously, to mimic its expression. When
it is the face of a bodiless head, our physical reflex – that
instinctive empathy – conflicts with the knowledge that this
person must be dead.[1]

Museums can and do change; they are not immutable.
In 2020, the Pitt Rivers Museum in Oxford removed
from display one of its most recognizable exhibitions
on the treatment of the dead (notably including what
are sometimes called 'shrunken heads' but are referred
to as 'Tsantsas' here), directly linking their presentation
to racism. The museum confronted this association,
provoking passionate responses both for and against

Figure 7.1: Pitt Rivers Museum signage

removal. What happens to a museum at such a moment? More broadly, this process is representative of wider conversations on change and the forms this can take in museums. Another example that links to the work of the Pitt Rivers Museum is environmentalism: what responsibility do museums have in global action on big issues such as climate change?

The Tsantsas of Oxford's Pitt Rivers Museum are closely associated with the institution itself, famous both locally and nationally. They were made around one hundred years ago by the Shuar people of the Andes and Amazonian Lowlands in Ecuador.[2] A human skull was removed from the body, together with flesh, skin and muscle, before being repeatedly refilled with hot pebbles and sand until the remains reduced in size to diminutive proportions. In a context of wider

faith-based practice, it's associated with accessing and harnessing the power of the dead individual's soul within violence.

The nineteenth- and twentieth-century colonial tourist trade became globalized, and both Tsantsas and their museum context moved far away from their cultural origins and morphed into an emblem of colonial tourism and violent acquisition.[3] So much so that demand outstripped access, and non-human material became incorporated. In the collection at the Pitt Rivers, for example, only a small portion of 13 Tsantsas are human remains. The others are animals or other organic matter, recreations made for a Western acquisition market that was buying them with unethical avarice.

The commodification of the Tsantsas and the 'shrunken head' iconography are pervasive in Western culture, for both children and adults. The film *Beetlejuice* (1988) and the Goosebumps books are just two examples. Another, the film *Night at the Museum* (2006), uses the trope of human remains within its storytelling. A toy shrunken head is available that quotes lines from a Harry Potter film. It's the most remarkable example of disassociation from what these are – emblems of violence.

Angela Billings (she/her), Development Director, Culture&, and doctoral student at the School of Museum Studies, University of Leicester, worked on understanding and quantifying public reactions to the removal of the Tsantsas from display at the Pitt Rivers Museum for her MA in 2020. Her conclusion

showed that a small number of negative voices were disproportionally amplified on social media. These loud voices utilized the now familiar attention-grabbing vocabulary of polarization – 'woke', 'PC', 'yielding', whilst 'quieter voices' (exemplified in her research by emoji reactions) went unnoticed. Using 'reactions' and not words as a measure of how the public felt about the removal of the Tsantsas, the response was overwhelmingly positive. In a generous conversation online, Angela helped me understand both the process and action of removal through her research.

Angela begins by exploring negative responses with us:

> I was struck by the personal nature of the comments, the personal attacks on the decision-making or on the institution itself. Some of the comments I would describe as criminal. At very close quarters I was sifting through the emotion of removal, getting people's heartfelt response to the removal of their entitlement to view the human remains of others. At the time there was no single automated social listening tool to allow a comparison across social media platforms and written correspondence, so I developed a manual method of categorizing the data. I felt strongly that it was important to capture the meaning implied through sarcasm, idioms, irony and tone.

This approach is an incredible testament to Angela's resilience and the determination of the institution to understand what was being 'said' about the removal. To understand the nature of museum removal is perhaps

to understand the nature of museum spaces as places that should hold the nuances of human experience.

Some of the letters in particular were very carefully constructed, the argumentation was academic and nuanced. However, that approach didn't hide the underlying message: 'I feel entitled to view the human remains of others,' says Angela:

> The very fact that the Tsantsas were displayed is an expression of the underlying imbalance of power; for some this power continues to be difficult to relinquish. I find it extraordinary that – feeling entitled to view – can be considered a valid argument. In this case, what was 'on view' were ancestorial remains – skin, bones, and hair. In addition, it was not just a skull on display, it was also their spirit.

There were calls at the museum for the Tsantsas to be removed long before 2020, but the pandemic provided a period when it was practically and curatorially useful to remove pieces. In times of turbulence, people tend to hold on to what feels safe – whether that's safe in terms of nostalgia, or in terms of their childhood, it's holding on to what we believe ourselves to be. Some people experience change as an attack on the very core of who they are.

Angela said, on the process of understanding museums,

> change is painful. To help us understand why, it may be useful to remember that, for many, the current presentation of Britain's colonial past is traumatic, representing a series

of 'holes', 'dents' and 'gouges'. Holes are historic erasures, the dents a visualization of how it feels when partial, subjugated history is embedded as truth, and the gouges are self-explanatory, they are the ongoing epigenetic physical harm of epistemic violence as defined by Spivak (1988).[4] If you try and consider this from a decolonial perspective, how can museums help to build affective resistance to those holes, dents, and gouges? What if, instead of colluding with this incomplete representation, museums push against it? Pushing against a wound hurt, both for those pushing and for those who inflicted the original injury. But what transformational interpretations might be 'heard' if museums listen to ancestral voices? Consider not what has been lost, because it was never yours to lose, but what could be *gained*.

'Courage calls to courage everywhere'

Let's open the conversation beyond our example to include two more guests in separate conversations. Professor Dr Laura Van Broekhoven (she/her) is the Director of the Pitt Rivers Museum, and Dr Njabulo Chipangura (he/him) is the Curator of Living Cultures at Manchester Museum. Both were interviewed online at different times and locations (complete with remote cups of tea), offering us insights into museums as they change and the voice of academia within museum settings.

University museums are not all the same although as with all museums they must be adaptive spaces, functioning within discovery. The work therefore to understand and react on the Tsantsas interpretation is

a requirement of the museum, yet the media can and does sometimes portray this as a 'knee-jerk reaction' to liberalism.

Laura joins us in reflection:

> We're emotional beings. [But] the Enlightenment created big issues around separating the rational and emotional, which leads to colonialism projecting some people as irrational. I think we need to bring our whole selves into the museum and allow visitors to do the same. Then we need to start questioning this idea that the emotional and the rational sides don't speak to each other. During COVID, the thing I missed was going into these spaces that fulfil me and my soul, make me feel and give me the time to explicitly think 'What is this doing to me?', when we weren't allowed to be our full beings. There was a loss of humanity, of who we are and that has a lot to do with art, being able to engage with each other and things that are beautiful, difficult, problematic.

One powerful dialogue taken to a binary and finite conclusion on museums is closure – are they so violent, locked in stasis and so irredeemably unethical that they should no longer exist? 'Completely removing exhibitions is not something we can do, or I'd want to do necessarily, or that the museum would benefit from,' says Laura:

> We are doing different things, such as 'curating the absence'. How we are seen is dependent on the political spectrum. That kind of work as potentially 'dangerous,

irresponsible' is because it moves away from the idea
of educational spaces of white capitalist colonial history
as people told it for a long time. Some are inspired by it.
When we did the UK-wide polling on regular museum-
goers, they find this kind of work important and an exciting
development. *'Courage calls to courage everywhere'*:
that's what I want to see museums do. That makes some
people uncomfortable because that's not what they want to
see, as too political, but for me it's what they are about.

We can challenge the notion that museums are risk
averse, or a level playing field – they are not. Removal
(and conversation on this within museum collections)
is therefore not necessarily radical or reactive, but part
of the life cycle of the display. Laura says:

On removal – some people considered this to be a larger
consideration for us. It really wasn't. The ethical side was so
clear to all our staff. Part of it was that it was lockdown; we
had done the ethical review. Front-of-house [the staff who
work directly with the objects and public in museums] were
really troubled by having the remains on display. We have
videos of them speaking of it as I wanted them to express
how they felt – it showed how important it was hearing in
their own words how they felt.

Laura continues with an example of how change is
generated in museums:

This summer I went to the Shuar people [Tsantsas were
made by the Shuar and Anchuar people of Ecuador and

Peru in South America] and spoke to several representatives to look at next steps, we are working towards an MoU [Memorandum of Understanding] where we agree what care could look like in the future. We have done CT scanning of the Tsantsa, and Ancient DNA analysis, and a mapping of where other Tsantsas are in museums around the world, over two thirds are in London – one of my goals for the next ten years is to decolonize the repatriation process. I want people not to have to jump through hoops to find and return ancestors. It's a colonial violence we are continuing. Sharing with staff about going to Ecuador, they were so pleased as they can tell visitors about this. For those that are still angry, it reassures that we are still working on the remains in research and consultation.

'Imprisoned in museums'

Njabulo joins the conversation separately in reflection of his journey within museums:

I was formerly a Curator of Archaeology for ten years, so from a Zimbabwean perspective, I'll start off from my working experience as a curator. I think the public perception, looking at how museums in Zimbabwe were formed, is still very much of fear. Fear of museums in Africa. In Zimbabwe, for example, most people are afraid of museum spaces because they were formed during colonization. They served a particular audience. Objects were not only appropriated and dislocated from communities, but they were also imprisoned in museums. They became object of the anthropological gaze.

Anthropology, for example, became one of the driving disciplines of collecting and imagining of other people's cultures, imprisoned in museums. Communities were very much detached from museums because, for them, museums were spaces where their cultural objects were imprisoned, stolen from original context, from where they were made, where they were used, not just as objects.

Museum language is also a huge consideration, and not universally accepted. Njabulo explains:

As an African, the word 'object' to me is problematic because they're not objects. They're living objects. They're living concepts, because they were made for a particular purpose, for a particular reason. So, when they were translocated and placed in a museum, they become objects. Why? Because they were being studied, they were being subjected to this kind of aesthetic. Objects are not meant to be frozen in the present. They are meant to be used, right? So, when they are used, they have a life, they have a biography. So [in a museum context they become] dislocated, disempowering of communities from their cultural objects, and imprisoning the objects. Western epistemologies of trying to study people's cultures. For communities, they became elitist.

Njabulo says:

Essentially, I'm a curator of anthropological collections with a deep, deep history of colonial violence. I'm responsible for more than 25,000 objects from all over the world, I

want to underscore that there has been a lot of colonial violence that led to them becoming objects at Manchester. They're not just anthropological collections. They are living; they live a life that was destroyed by colonization. I think museums in Europe, for example, Manchester, we're trying as much as possible to infuse the ethic of care, inclusion. I'm not supposed to be the sole authority of knowledge production on people's cultures and people's heritage. I think the discussion is going towards being a facilitator of dialogue.

So how do we do this? We must be accountable for what we hold to the public. And our public are diverse. How do we bring diaspora communities to Manchester Museum, and how are we allowing them to know what we hold, and what kind of stories can we generate from them as experts? What is the space for indigenous knowledge systems or what we call lived experiences? How can we bring lived experiences into a museum? Producing in co-production new narratives on these objects that were orphaned for a long time, imprisoned, caged, in our storage rooms. It's about inviting the public to our collections.

Courage. Accountability. Self-awareness. These are universal messages museums can and should amplify.

Reimaging 'loss' in museums

The dialogue on 'loss' of collections can be emotionally charged – with the negative characterization of empty cases, museums without pieces and objects museum-goers grew up with. Is that the inevitable reality?

'The appetite for growth has been what museums were set up for – the need to keep on accumulating,' says Njabulo. He continues:

> I think I've argued this in my writing that I don't even think restitutions really is synonymous to decolonization. I think people are missing it because it's a shorthand for being politically correct. We're replicating the vehicle of the distress in the place where the violence was created in the first place, I become very suspicious. Museums are still going to control the conservation ethics and the funding. ...
>
> I think the conversation for me is really fascinating in how we can approach restitutions and repatriations in a collaborative mode. Let's not leave restitutions and repatriations as an exercise of power and authority by curators who are just exchanging conversations. Curator-to-curator power-sharing is not power-sharing. There's no equity in that. You're replicating the colonial model; therefore, you're replicating the colonial violence that followed. Let's try as much as possible to help people take charge of restitution themselves.

Pitt Rivers and removal

Laura offers a practical example:

> When we drafted the repatriation procedures, one of the things some of our volunteers were concerned about was that well-known pieces would return, such as the totem poles. However, in the Peabody Museum, for example, a new totem pole was made in its place (by the indigenous

community represented). You want people to start rethinking the idea of 'loss', and the only thing repatriation can do for us is loss. Instead, we can start to think can there be a *gain* for us?

Let's apply this to marking the removal of the Tsantsas, and the new interpretation around this. Laura reflects,

Writing the text I tried to start with a partly intellectual and reasoning level giving information, but also to be political in the text in saying, on the one hand, indigenous people speaking, and voices are theirs, 'This is not what we want. We have the right be buried and stay buried. We are human too.' I tried to make a mix of that approach.

The space formally held by the Tsantsas hasn't been re-curated, refilled or removed. Instead, it stands as a monument, a deliberate absence drawing attention to the space. It holds the act of removal visually and emotionally as a spectacle in itself, a functional decision radiating dialogue on equity and faith. It is still an exhibit; however, a radical departure that stands out from its surroundings with intent. Laura muses:

Why were people so troubled at the removal? Because we are not listening to that part of the story that calls [the original] removal (holding this object in the UK) theft of their heritage. Actually, we are listening to indigenous communities and are working around those voices. You're changing the power balance and saying, 'Whose voices are being heard, whose experience do we prioritize?'.

Curation as segregation

Curation and how museums organize, segregate and catalogue pieces can be framed as an attack, a disruption, damage to a life both pre- and post-death that needs to be recognized. A number of these objects were not designed to survive, rather designed to have a finite lifespan. That they exist now in a museum would be not only surprising but emotive and challenging to the makers. By opening the museum stores and making sure that people are equipped to make informed decisions, communities can be part of this conversation.

'I think museums take so much pride in numbers,' Njabulo says. 'Manchester Museum is the largest university museum. That's not a good thing. Quantity doesn't reflect any ontological differences, because we have similar pieces. Museums don't want to return [objects]. Why? Because museums fear losing the count of numbers. If they return five, then they are no longer the biggest.'

The culture of numbers is a narrative within museums because of the colonial status of quantity and volume. That the cost of this is violating someone both in life and death speaks of a tension between museum access versus removal. On the removal of the Tsantsas, rather than refill the space, Pitt Rivers Museum has memorialized that absence. It has held it as an ethical statement.

'I'm currently rewriting our human remains policy at Manchester University Museum, thinking about rehumanizing,' Njabulo tells me. He continues:

We need to move away from thinking of them as human remains or 'mummies', as we call them. They are the ancestors of living people. They were dehumanized by colonial violence, subjected to different regimes of scientific studies for more than a century in little boxes and labelled. They've been subjected to many, many anatomical, physiological studies. For me, the process of rehumanizing and reburying is a very simple process. Let ancestors rest in peace.

This approach speaks of genuine empathy. A CT scan will subject a human remains to radioactive particles, which is again as intrusive as penetrating the remains.[5] You are still processing and analysing it, even if the process of doing so isn't using your hands. The Tsantsas' removal stands out here as an emotive example; further display reinforces racism, othering. Having conversations with the representatives of the Shuar people is to understand that they do not want these objects on display. Many human remains cannot return home (if home still exists), but they don't have to be publicly scrutinized. They can have respect and a decency being away from that gaze.

Njabulo expresses the hope 'that museums are going to become spaces where communities come and commune and have conversations'. He continues:

But it took quite a long time for postcolonial museums to really think about communities and bringing them to the museum. When I took up archaeology for my first degree, my parents asked me, 'Why do you want to become an

archaeologist? What is that? Are you going to do grave robbery?' That's how people still perceive archaeology and the museum. Why? Because of the violent history of colonization and how museums served as a function of colonization. Objects and graves were just looted. So, most people still perceive the museum as this object-appropriating centre where their objects were stolen away from. Archaeologists are literally undertakers, so perceptions in an African context are improving, but there's still a lot to be done in terms of reconciling the museum as a space that has not only kept objects taken from people, but also has leeway to have dialogue with those communities from where objects came.

Removal is not part of the perceived life cycle of the institution but perhaps it should be; the institution is designed to grow until it can't fit any more in, always adding new history. Reorientating that within humanity shows us that removal is not only part of the natural life cycle of these objects, but also of the natural life cycle of our museum access, because from removal new conversations, new sociology and new moments can grow. Museums arguably should be seen as a state of both addition and reduction.

Environmentalism considered

The future of museums must be considered within how far it can stretch to meet rapidly expanding populations and a climate emergency – do they fail as generalists or become good specialists? Environmentalism is a key

manifestation of change that the Pitt Rivers Museum faces as its collection dictates a world view, with travel and connection. The pieces and relationships must connect as global citizens. While this can be offset by online access, there arguably remains a need for physical interaction, which Laura recognizes. 'It will mean we need to fly and go, especially in repatriation; we have done all the work we could do for years online, but people want to see a person.'

Taking it back to our piece in profile, Laura returns to reflect on working with the Shuar people as an example:

> We are doing a lot of work with indigenous people who are affected by conservation work. I'm not saying it's good that we fly (we compensate for the CO_2) but we're conscious that this can be at the detriment of indigenous people, because they're the ones who are evicted from lands during tree planting for example. It's balancing out function but not using more than we need to (such as paperless and plastics in the building). It's important not to be hypocritical but work with integrity.

With its huge privilege, the museum can draw attention to environmentalism as a part of how it operates. It consumes but is also a platform to *challenge* consumption. Consistency in action is where trust is born but can also die. If museums continue to exist within environmentalism, can they do so positively?

Environmentalism and human-centred narratives

Njabulo suggests a key question is:

> How can museums step into the conversation of
> advocating for environmental justice? Museums can
> be spaces for social change, not just object-collecting
> centres, but they can also be spaces for dialogue. Those
> objects can be used to think about how we can challenge
> contemporary, topical, social issues. I think access really
> in most cases is quite problematic. I went to Africa recently
> doing research on traditional Zulu beads. We went to the
> community. The need for us to go was there; however, on
> an environmental level there's a carbon footprint. What
> can we do now to strike the balance? For me, we take
> advantage of online facilities and conversation online.

He offers a useful example:

> If you look at cultural objects, some of them reflect changes
> over time and how maybe in the past, communities in
> their own ways considered the environment using what
> I call traditional management systems. So, in Africa, for
> example, there are many conservations that are purely
> based on spirituality, religion and rituals. We have at
> Manchester Museum traditional drums. When I was in
> Mutari in Zimbabwe, I did a study of these drums. I found
> out that instead of them thinking of them as just drums, as
> functional making noise, they were used by communities
> for what we call rain-petitioning ceremonies. They would
> beat them, celebrate and do rituals to ask the gods for the
> rains. I think that's part of environmental justice.

This reframes these museum objects as part of a physical ecosystem, not as decorative objects but as objects people used spiritually to create a relationship with rain. Reframing the objects within that context gives them purpose in terms of environmentalism and reinforces their humanity.

What are museums for?

Laura suggests they are:

> meeting places for people where they can be inspired, reflect, think together. The work we do is to be part of a process of change and for the work we need to do at Pitt Rivers to be part of a process of healing – reconciliation, reaching out to communities, being there as a listening place. Where we can amplify through co-curation, be a place where joy can be celebrated, on the one hand, in music and programming – at the same time a place where repair can happen. Repair of trauma, exclusion, redress and therefore places of hope. Hope in the work that we do and where love is celebrated.

Njabulo offers:

> Museums are not for objects per se. Museums are supposed to be spaces to tell stories about the objects, not on the objects. Museums are supposed to be for dialogue. We can speak about colonial violence directly in a museum because museums have got traces of colonial violence. Museums are supposed to be spaces for

practice. Museums are supposed to be truth-telling spaces – action through multi-vocality, recognizing that we all here are not just materialities of anthropology, ethnography or archaeology, but living culture for living people. I think the purpose of museums is for them to function as these open, democratic spaces for dialogue, where they practise shared authority in knowledge production. Objects are a function of stories; they have an underlying intangible use and value. Museums must tell those stories.

Museums help us remember together – both the good and the bad. Spaces that memorialize chains of action for our use. They give us perspective on change, and with it the emotional space to feel the emotion of change. Perhaps that's what they are for – reminding us why change is so important.

8
THE FUTURE MUSEUM?

H ere I want to return to the original piece in the Ashmolean we explored in Chapter 1, now enriched by the conversations we've had in the past six chapters. Sitting in front of the exhibition, I reflect: Chapter 2 reminds me that all museums are manifestations of power – soft, often invisible, and yet capable of pulling on us with ferocity. Chapter 3 makes me feel the value of how we tell stories, to share these in care for ourselves and for others. Chapter 4 draws my attention to the reality that museums exist not just within their walls but literally in our hands via a smartphone, based in our agency and need. Chapter 5 reminds me that museums and all within are a complicated conversation on trust which must be in the forefront of all our thinking. Chapter 6 shows me that we all live and experience the world at intersection – and that this can be and is where new history happens. Chapter 7 demonstrates to me that all museums change – as they must if they are to be part

of our present and future. In applying each chapter's learning, I shift, ever so slightly, in how I feel about the Ashmolean exhibit. Am I closer to answering the question in the book's title? A few steps closer.

What next?

Museums will inexorably continue to be linked with potential controversy; the nature of contested narratives, though, continues to adapt. Louvre Abu Dhabi, for example, in Dubai (since 2007) has faced accusations of human rights abuses during construction, plus challenges to the museum's ability/willingness to take part in truth-telling. Shifting global positioning on where and how museums operate expands the voices within museums, and how they in turn impact lives. Museology adapts, changes or is rejected in finding new relevance in the world. The future of museums will be (and should be) vigorously challenged.

The word 'museum' itself (and therefore its perception) will also adapt. The Museum of Ice Cream is an example of a retail and social media experience which uses the term 'museum', yet it's a limited company that develops, markets and operates interactive retail experiences, or 'selfie museums', situated in the US and Singapore. Exhibits are typically storefronts, sets to pose within, selling ice cream and confectionery. They serve as places both to buy the food and to curate your social media presence on camera. Visitors are greeted not with a collection of objects, an acquisition policy or civic function, but

instead a pop-up experience tailored for the social media age at $50 per person. Vibrant pastel graphics and video graphics entice us to have wholesome fun, curated as a commercial package. Founders Maryellis Bunn and Manish Vora first opened the museum in New York during the summer of 2016, with Bunn describing the American retail sector and traditional museums as a 'dead industry' and 'archaic'.[1]

A retail experience can reimagine its existence as something new – to call itself a museum is to become one. Reclamation? Reinvention? Appropriation? The museum brand is so powerful it can function without the museum apparatus that defines it. Perhaps that's the future museum? An evolution of the word 'museum' with organizations we would not necessarily expect to be museums, unlocking the cultural capital, potential and reach of the word. Does this also, though, to a degree dilute the word 'museum' and what it can be? Narratives of misappropriation of the trust people place in the word 'museum' can and should be challenged by values-led museum engagement – they must demonstrate their ethics, collections and stories within a competing landscape of 'museums' in multiplicity rather than one singular notion of the museum.

Museum change could be in some cases seen as negative, reductive or possibly deceptive. However, change also blossoms with hope and renewal – as seen in the UK's Museum of Homelessness (MoH); for me, one of the most persuasive and beautiful templates of museum evolution. MoH was founded in 2015 and is

created and run by people with direct experience of homelessness. It acts within political and social change, holds and collects pieces reflecting this narrative and operates dynamically in multiple geographical locations. Its charter[2] highlights four key functions:

1. We make tomorrow's history by building the national collection for homelessness
2. We take direct practical action in support of the community
3. We fight injustice with our independent research and campaigning
4. We educate on homelessness by working with artists and creatives to make unforgettable art, exhibitions, and events.

Two powerful recent achievements include MoH being named as one of the awardees for the Calouste Gulbenkian Foundation's first Awards for Civic Arts Organisations (in the UK) in recognition of its work in the pandemic. Secondly, the MoH exhibition Secret Museum was named Temporary Exhibition of the Year at the 2022 Museums and Heritage Awards. Bold, purposeful, ethical and active civic agents in changing lives.

Let's have a final conversation drawing on all the chapters with three amazing voices in the museum world, interviewed either online or, in the case of Sharon Heal, in a central London meeting room, sharing chocolate cake. I return to my key questions of where museums came from, where are they now and where are they going, inspired by previous chapters.

Joining us are: Richard Sandell (he/him), Co-director of the Research Centre for Museums and Galleries, which is part of the School of Museums City at University of Leicester; Susan Anderson (she/her), PhD, Assistant Professor, Museum Studies, George Washington University, Washington, DC; and Sharon Heal (she/her), Director of the Museums Association in the UK.

Reflecting on where museums came from and where they are going

'It depends where we sit geographically and who we are,' says Sharon. She continues:

> The perceptions of museums are probably very different if you take yourself out of the museum bubble and stand outside as a member of a community. That will really vary depending on whether you feel welcome or wanted. If you come from an identity that has been traditionally excluded/not been welcomed into those spaces, you will have a very different view from somebody who feels at home in those spaces. ...
>
> As a sector, we're at an interesting turning point – re-focusing and re-shifting away from just an obsession with the collection. The collection is still the unique selling point, the objects that museums have are amazing and can tell a thousand different stories. When you put them together with communities, that is transformative. The shift of focus now is from within the institution to who's outside it.

That, she says, echoing many of our interviewees, has been brought into especially sharp focus because of societal changes in the last decade 'that has made us, everyone in society, at an individual level and collectively, reckon with our role, our purpose, our families, our lives, our work, our careers'.

Susan picks up on this theme:

> Museums were created as spaces of lauded culture and to bring together culture knowledge, so much of what's in them is connected to histories of pain and that tension between 'we are here to glorify', 'to show the best of', 'to educate'. We are holding objects associated with pain and trauma that is very real and very tangible and has been linked to ongoing inequity. That's one of the things that the sector is grappling with.

For some visitors, the past is locked in the past. Yet in museums, as society and our dynamics, interpretation can shift rapidly.

'There's something in the rich history of museums, without being nostalgic about it, that we can learn from,' suggests Sharon. She continues:

> We need to not repeat the cycle. One of the things that's really struck me in the past five years when we've been talking about decolonization is that the people who've understood it in the museum and cultural sector and the academic sector in the UK have been talking about this for decades. Don't treat it as something that's resolved by one exhibition that talks about global

voices or international narratives. It's more than that, it's fundamental, and as a society, and as a sector, we've got to come to a reckoning with our history of empire and links to slavery.

The precariousness of balancing is what museums are, in a sense. First and foremost, for some people, they're an emotional hug, joyous, one of the few places in society they can linger, possibly not spend any money, and feel included. Museum duality can, however, be wrapped in negativity – they are structured approaches to categorizing the other. Simultaneously, their aim is also egalitarian – for everyone to be involved, but on the terms of the people who founded them. Everyone is welcome, arguably so long as you fall into the categories that museums understand you to be in, or perhaps if you can afford the entry fee. Balancing that constant inherent tension of positive and negative experience is an extraordinary example of what museums are. It's soft power, but it's inescapable power. It speaks of being egalitarian, but it's trust presumed, rather than earned. More fundamentally it belies the pull of what these spaces are, which is warmth and togetherness, or occupation after huge levels of violence. All this rooted in a process of constant social change and expectation.

Where are we now?

'With all their faults, museums really matter,' says Richard. He explains:

However, they still only attract certain kinds of audiences. (Some) turn their eyes to museums and heritage sites to hold them to account, to make them better, to highlight when they were doing good and when they were doing bad. What museums do really matters to them. I take it as a challenge and reassurance in that what museums are doing and talking about is important. The perception that many museums have is one of trusted authority – 'museums tell it like it is'. It bleeds out into our public discourse through the media, through word of mouth; museums have this capacity to narrate the shape of conversations.

To ground us in the contemporary museum experience, Richard offers an example which deeply affected me emotionally as a visitor:

In 2017 when University of Leicester Museum Studies School were a research partner on the exhibition 'Prejudice and Pride' with the National Trust site Kingston Lacy to create an installation called 'Exile'. This interpreted the story of William John Bankes' exile and forced departure from the House of Commons in the UK because of being caught having sex with a soldier [an illegal act in the UK at the time (in 1841), well before partial decriminalization in 1967]. A rollercoaster of opportunity and challenge and quite an amazing thing to be part of that. A visitor wrote to me afterwards, talking about looking after his elderly parents, visiting, and he described experiencing homophobia from fellow visitors. Yet he wrote to say thank you for the project. We had so much

controversy around this project, so much push-back and complaints; how could somebody be exposed to that experience and write and say thanks? My shorthand for it, having deeply thought about it, is, obviously the National Trust and that property had been complicit in erasure over not consistently telling this story before. But, through all the challenges, what they did around that story was stick to their guns and make clear, even in the face of a very extreme national-level controversy, that they wouldn't dilute the programme and stuck with our plans. The organization explicitly stood for LGBTQ+ equality at that moment, and a celebration of growing rights enabled that visitor to have both a horrible experience and to write and say thank you.

Figure 8.1: Exile installation at Kingston Lacy

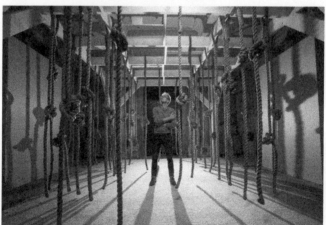

Many pivotal recent social moments continue to influence us. Richard continues:

> The Black Lives Matter movement was a moment when
> museums had to make some kind of public statement,
> especially those that acknowledge their complicity. They
> let down that wall of museums being somehow separate,
> somehow aloof, restrained, impervious to all that world.
> There was a moment in terms of shifting perceptions that
> museums at their best are relevant in everyday discourse,
> at the heart and to-and-fro of society thinking and debate.

Intersectionality is the heart of care, to not profile our identities but recognize that we're part of a bigger story. Care can only fully be realized by a museum institution when it has a workforce that's representative of the lived experience that people need to access that care.

'There isn't one public,' Susan emphasizes. She continues:

> There are so many. It's easy to talk about a loss of trust
> with a general public. You might say, 'the public doesn't
> care about this'. but specific publics do. Publics with a
> relationship to a set of objects, publics with investment in
> the story, publics with a connection to the thing that you're
> telling. That is very important. Thinking of 'a general public'
> is a recipe for inertia. Change happens in response to
> specific people and specific publics who say, 'Actually, this
> practice that you're doing is not acceptable.' I personally
> think that that's where you should be prioritizing, those who
> most explicitly have a connection and a conversation. The

stakes are higher in the investment. Part of that is because trust is specific, trust isn't general.

The most powerful critique comes from love, and should be in the service of transformation. So, if we seek to critique an institution, it is with the intent of creating something new. That must recognize power relationships and imbalances, donors and their influence, for example.

Susan moves our perspective across different countries and privilege:

> We live in a plutocratic environment where philanthropy is so much a part of the model. In the UK, in Australia, the systems that I'm most familiar with, we are also still beholden to the people who have the stuff we want. Museums don't necessarily have big budgets for purchasing. We're reliant on donations. If we're thinking about the need to please donors, we can't then be too scathing in our critique because we need to be able to attract objects from those who have them, who want, who need to be able to trust us. One of the publics we're talking about is a donor public, and they need to know that what they're donating will be cared for and appreciated in the way they would appreciate, but also that their reputation is safe with the museum. So again, critique is so important. Pulling apart the practice of museums is helpful in thinking about how we transform the practice of museums, but also there is this inherent tension where museums must still look after their donors.

'They exist to persist'

Susan explains:

> A challenge that we run up against is the nature of
> institutions. Institutions exist as codified conventions that
> solve social problems. We have decided on a social
> problem, we need to be able to capture and hold on
> to the past and present in some in some way to use it
> and prepare for the future. Institutions created policies
> and processes and practices. They are slow to change
> because they exist so that we don't have to come up
> with an individual answer every time we try and solve a
> problem. They exist to persist. The purpose of institutions
> is to enable persistence over time. They do change when
> individuals or communities become invested in particular
> kinds of change. They push change, but that change
> becomes co-opted into the institutional model. It becomes
> naturalized. It becomes legitimized as the institution's
> way of doing things and so it loses the radical edge. It
> sort of becomes nullified. If you're perceived as attacking
> museums, the institutional mechanisms of the museum might
> seek to bring you in and legitimize you. In that, the attack
> loses its bite. If you want to change museums, changing
> who is included within that set of individuals is absolutely
> critical, as is changing the practices of the institution.

Museums have legacies in the form of buildings. The
building is both an opportunity and liability when
it comes to change. Collections are both where they
draw a lot of power from and something they must
reckon with. However, the museum can't change on

its own. No matter how good the aims are, no matter how progressive the people are within the institution, museums are as liable to, as good as, and as productive of the many different ecosystems that they inhabit. Museums are designed to grow, designed to spread their tendrils across society. The museum is part of nationalism, it's part of regionalism, it's part of our identities, it's part of civic function, it's sometimes part of our taxes. There are so many different competing factors inside of them.

Where are museums going next?

Figure 8.2: Museum of Homelessness

I ask Sharon this question, and she responds:

> There's a future museum that is being created now. It's been
> created from scratch, and it's been created by communities.
> It's nothing or very little to do with what people who work
> in museums would normally recognize as a museum. Take
> the example of the Museum of Homelessness in the UK.
> I think that is one view of the future of museums because
> it's a different way of working. Ultimately the aim is to
> capture the voices and the stories of people who have
> been ignored, disenfranchized and marginalized because
> of their lived experience of homelessness. It's about
> campaigning, it's about direct delivery, it's about working
> with people who have that experience, and not just
> working with them but absolutely centring their experience
> and their voice at the heart of the institution. A small
> example: at the beginning of the pandemic the museum
> shifted its operations from temporary exhibitions and
> working with objects to direct delivery of food for people
> who were in temporary accommodation and those still on
> the streets. I think to me that's an example of what the future
> museum could be – centred on community and community
> space. Light on their feet, nimble, a different sort of practice
> and tradition.

So, this envisages de-establishing the museum model,
but taking and using that historical legacy it still carries
with us consciously. Museum objects are not the only
starting point, rather the objects are a by-product of
the creation of the museum itself. Reversing that trend
of starting with objects and building the museum from

that to instead the social mission of what a museum is, and then filling it with the by-product of how people define that. Added to this, the shift to digital engagement and access is crucial in that conversation (or perhaps needs the most development), because for the first time we have a reckoning in our communities that people can access museum content on their terms. There are still barriers in terms of digital, but arguably for the first time we have active channels where people can access museum collections anonymously and not have to be categorized by the institution.

Museums for Sharon are emblematic of action:

> I don't think we should be here to represent the status quo. These are not neutral spaces. Even if you are a 'white cube' gallery with no permanent collection, the decisions that you make about what goes on the walls, the interpretation, etc., are decisions of the institution and the individual. If we're not neutral spaces and we have public funding, that means we need to make a contribution to society. I fundamentally believe in public funding for museums and for our cultural sector. If we get that funding, we need to make a positive difference; that can be anything from preschool sessions that allow informal learning to take place, to decolonization and thinking about the history and the legacy of empire and slavery. It's also about environmental and climate justice and thinking about how contemporary issues are captured in our historic collections and our contemporary collections. Beyond that, then I think it's looking at the big issues that we face in society – poverty, discrimination, inequality, climate crisis, racism,

divisions in communities. We need to be asking 'What role do we play and what use can we be working with our communities?'

Museums occupy a position of civic care and often have considerable resources. Yet they are unelected, arguably self-selected in increasingly smaller and smaller pools based on specialism or privileged access to collections. Activism can and does hold this accountable.

'One of the things that I think about a lot on the future of museums', Richard says, 'is museum activism.' He continues:

> We were clear what we mean by activism when publishing the book *Museum Activism*[3] in 2019; it's harnessing the museum's unique resources to function as a force for good in the world. It's the shorthand really. A willingness to accept that there are responsibilities and possibilities. Museums should harness them for good. It's quite benign, normative, everyday. Our intention was to suggest it as not just an optional activity, but as the orientation for all museums, a way to make museums think mindfully about what they do, capacity to have harm, value and benefit, and to make the right choices around that. We knew we were slightly mischievous using the word 'activism' with all its loaded baggage, but since we published it, I've seen it used more and more pejoratively, not just by sort of culture warriors outside, but by some forces within museums who coin the term 'activism', always referring to something destructive, something dismantling, vandalistic. My response to that is increasingly in the work that I'm doing

with cultural organizations and students. I'm not just talking about activism as ethics, but activism [from people who are] outsider – never destructive. We harness museums to do good in the world, why can't we just rethink the museum model so that that's at its heart? That's what I'm driven by – a recognition – the growing professional recognition that museums are not neutral. As it gains traction, it also prompts a backlash. That backlash is from powerful forces trying to keep the museum not in that space. My push for the future and what is to reclaim that not as this optional thing, but as at the heart of all museum – good ethical work.

On museum activism, Susan, adds:

Grappling with something that isn't past, that is still very present in people's lives – that's all museums. Intergenerational trauma is real. It does continue and it has an impact on people's lives today. Talking about the impact of being in that space and having a reaction and a response to the emotional weight of what was happening, I think for my students that is often something that becomes present for them in a very real way. Sometimes for the first time, not always, but for some of them this realization of we might need to be collecting from a terrorist attack [a powerful example being the 9/11 attacks in New York and the subsequent establishment of the non-profit 9/11 Memorial Museum] or we might need to be holding onto objects that are very traumatic. We need to think about respect and dignity in terms of the presentation of them, but also the people who are working with them. We're

seeing more people starting to acknowledge the need
for museums to be trauma-informed and for museum staff
to be trauma-informed, but also that's not necessarily
part of the training for museum professionals coming into
the profession.

Museum buildings are designed to stand for hundreds
of years. Yet now they have a duality with the digital
world. Susan asserts:

We absolutely need to be engaged in a digital space.
It's critical. It is where culture is taking place. Museums
should be involved in collecting and how we think about
collecting the digital. We also need to think about the
responsibilities of which platforms we work for and how
that contributes to the spread of museum culture, including
the reification of the existing limitations that we have of
those legacy collections. Certainly, here in the US, they're
having unionization conversations, and in the UK as well.
There's interesting work happening in New Zealand, in
Australia, around biculturalism, with national museums and
First Nations communities building a model that seeks to
be, although we're not there, but seeks to be more based
around consent. Museums are these incredible adaptive
institutions. They must be. That's how they survive.

On innovation, Susan suggests:

there's power in the idea of the museum, right? But
that power can be used and co-opted. If we look at in
America, the Black Museum movement [an example

being the National Civil Rights Museum, Memphis,
Tennessee] is so powerful and created, I think, something
a lot closer to the consent model, with community-focused
storytelling, storytelling that is so much about persistence
and resistance, and finding power in that. It takes the idea
of museum but uses it to create conditions for thriving,
conditions for stories that could answer back to the
oppressive structures of museums.

Susan generously offers this final sharing, which has
impacted me deeply:

Museums only exist and only have power because of
the power that we give them, but also that power is what
we can use. The institution's power is power we can
co-opt. That's why there continues to be the power of
storytelling within museums. Making sure that there's broad
representation in the stories museums tell is vital.

Perhaps after reading this, you'll pass by a museum,
visit one or digitally scroll through museum content.
Are you ready to ask the question – 'What are museums
for?' I, we, and all those around you may be the answer
if we ask in unison.

NOTES

Chapter 1

1. Angela Stienne, *Mummified: The Stories behind Egyptian Mummies in Museums*, Manchester University Press, 2022, p. 17.
2. Angela Stienne, *Mummified*, p. 5.

Chapter 2

1. Robert R. Janes and Richard Sandell (eds), *Museum Activism*, Routledge, 2019, p. 7.
2. Lucilla Burn, *Hellenistic Art: From Alexander the Great to Augustus*, British Museum Press, 2004, p. 65.
3. Lucilla Burn, *Hellenistic Art*, p. 11.
4. Lucilla Burn, *Hellenistic Art*, p. 63.
5. Lucilla Burn, *The British Museum Book of Greek and Roman Art*, British Museum Press, 1991, p. 130.
6. Lucilla Burn, *The British Museum Book of Greek and Roman Art*, p. 132.
7. See https://www.bbc.co.uk/news/science-environment-15257259
8. David M. Wilson, *The British Museum: A History*, British Museum Press, 2002, p. 15.
9. David M. Wilson, *The British Museum*, p. 10.

Chapter 3

1. Nuala Morse, *The Museum as a Space of Social Care*, Routledge, 2021, p. 175.

Chapter 4

1. John Byrne, 'Becoming Constituent', in John Byrne, Elinor Morgan, November Paynter, Aida Sánchez de Serdio and Adela Zeleznik (eds), *The Constituent Museum: Constellations of Knowledge, Politics and Mediation*, Valiz, 2018, p. 27.

2 It should be noted that The Met cannot confirm nor deny the existence of the kernel of popcorn. This was looked into it while producing the episode, and there is no formal record of the event. This anecdote (whether real or imagined) became the basis for E.L. Konigsburg's famous book *From the Mixed-Up Files of Mrs. Basil E. Frankweiler*, in which two children run away from home and seek refuge in the spaces, on the furniture, and among the other artwork at The Met.

Chapter 5

1 Simon Prince, *Northern Ireland's '68: Civil Rights, Global Revolt and the Origins of the Troubles*, Irish Academic Press, 2007, p. 200.

Chapter 6

1 David J. Getsy, *Queer (Documents of Contemporary Art)*, Whitechapel Gallery, 2016, p. 15.

Chapter 7

1 Frances Larson, *Severed: A History of Heads Lost and Heads Found*, Granta, 2014, p. 9.

2 Larson, *Severed*, p. 18.

3 Larson, *Severed*, p. 21.

4 "Can the Subaltern Speak?" by Gayatri Spivak, first published in 1988, is a noted essay on postcolonial studies. It features analysis of contemporary reflection on postcolonial legacies.

5 Angela Stienne, *Mummified: The Stories behind Egyptian Mummies in Museums*, Manchester University Press, 2022, p. 189.

Chapter 8

1 https://nymag.com/intelligencer/2017/10/museum-of-ice-cream-maryellis-bunn.html, see also https://www.museumoficecream.com

2 See https://museumofhomelessness.org/who

3 Robert R. Janes and Richard Sandell (eds), *Museum Activism*, Routledge, 2019.

FURTHER READING

Chapter 1

Arthur MacGregor, *The Ashmolean Museum: A Brief History of the Museum and Its Collections*, Ashmolean Museum, 2010.

Angela Stienne, *Mummified: The Stories behind Egyptian Mummies in Museums*, Manchester University Press, 2022.

https://www.angelaspalmer.com/eygptology

https://www.ashmolean.org

Chapter 2

Lucilla Burn, *The British Museum Book of Greek and Roman Art*, British Museum Press, 1991.

Lucilla Burn, *Hellenistic Art: From Alexander the Great to Augustus*, British Museum Press, 2004.

Robert R. Janes and Richard Sandell (eds), *Museum Activism*, Routledge, 2019.

Rupert Smith, *The Museum: Behind the Scenes at the British Museum*, BBC Books, 2007.

David M. Wilson, *The British Museum: A History*, British Museum Press, 2002.

https://www.legislation.gov.uk/ukpga/1963/24/contents

Chapter 3

Jane Farrington, *The Pre-Raphaelites at Birmingham Museum and Art Gallery*, Birmingham Museums Trust, 2015.

Ellen McAdam, *Birmingham Museum & Art Gallery Guidebook*, Birmingham Museum & Art Gallery, 2017.

Meredith McKendry (ed.), *Building the National Museum of Australia*, National Museum of Australia Press, 2015.

Craig Middleton and Nikki Sullivan, *Queering the Museum*, Routledge, 2020.

Nuala Morse, *The Museum as a Space of Social Care*, Routledge, 2021.

Julian Treuherz, *Ford Madox Brown: Pre-Raphaelite Pioneer*, Philip Wilson Publishers, 2011.

Chapter 4

John Byrne, Elinor Morgan, November Paynter, Aida Sánchez de Serdio and Adela Zeleznik (eds) *The Constituent Museum: Constellations of Knowledge, Politics and Mediation*, Valiz, 2018.

Herminia Din, Phyllis Hecht and Selma Thomas, *The Digital Museum: A Think Guide*, American Association of Museums, 2007.

Howard Hibbard, *The Metropolitan Museum of Art*, Harrison House, 1988.

Caroline Wilson-Barnao, *Digital Access and Museums as Platforms*, Routledge, 2021.

Keir Winesmith and Suse Anderson, *The Digital Future of Museums: Conversations and Provocations*, Routledge, 2020.

https://www.metmuseum.org

Chapter 5

Karen Logan, *Collecting the Troubles and Beyond*, National Museums NI, 2018.

David McKittrick and David McVea, *Making Sense of the Troubles: A History of the Northern Ireland Conflict*, Penguin, 2012.

Simon Prince, *Northern Ireland's '68: Civil Rights, Global Revolt and the Origins of the Troubles*, Irish Academic Press, 2007.

Andrew Walsh, *Belfast '69: Bombs, Burnings and Bigotry*, Fonthill Media, 2015.

https://www.nationalmuseumsni.org

Chapter 6

Clare Barlow, *Queer British Art: 1867–1967*, Tate Publishing, 2017.

Adam Nathaniel Furman and Joshua Mardell (eds), *Queer Spaces: An Atlas of LGBTQIA+ Places and Stories*, RIBA Publishing, 2022.

David J. Getsy (ed.), *Queer (Documents of Contemporary Art)*, Whitechapel Gallery, 2016.

Charlotte Keenan, *Coming Out: Sexuality, Gender and Identity*, National Museums Liverpool, 2017.

Alex Pilcher, *A Queer Little History of Art*, Tate Publishing, 2017.

The Walker Art Gallery Official Guide, National Museums Liverpool, 2012.

https://www.liverpoolmuseums.org.uk/walker-art-gallery
https://mattjsmith.com

Chapter 7

Julia Cousins, *Pitt Rivers Museum: A Souvenir Guide*, Oxford University Pitt Rivers Museum, 1993

Dan Hicks and Alice Stevenson (eds), *World Archaeology at the Pitt Rivers Museum: A Characterization*, Archaeopress, 2013.

Frances Larson, *Severed: A History of Heads Lost and Heads Found*, Granta, 2014.

Alice Procter, *The Whole Picture: The Colonial Story of the Art in Our Museums & Why We Need to Talk About it*, Cassell, 2021.

Laura Van Broekhoven, *Entangled Entitlements and Shuar Tsantsa (Shrunken Heads)*, Routledge, 2023.

https://www.bbc.co.uk/news/uk-england-oxfordshire-54121151

https://www.prm.ox.ac.uk

https://www.prm.ox.ac.uk/shrunken-heads#:~:text=The%20decision%20was%20taken%20to,racist%20ways%20about%20Shuar%20culture

Chapter 8 (General reading to continue your interest)

Orian Brook, Dave O'Brien and Mark Taylor, *Culture is Bad for You: Inequality in the Cultural and Creative Industries*, Manchester University Press, 2020.

Katy Bunning, *Negotiating Race and Rights in the Museum*, Routledge, 2021.

Corinne Fowler, *Green and Unpleasant Land: Creative Responses to Rural England's Colonial Connections*, Peepal Tree Press, 2020.

Dan Hicks, *The Brutish Museums: The Benin Bronzes, Colonial Violence and Cultural Restitution*, Pluto Press, 2020.

Suzanne MacLeod, *Museum and Design for Creative Lives*, Routledge, 2021.

https://museumofhomelessness.org

https://www.museumoficecream.com

INDEX

References to figures are in *italics*. References to noted material are the page number followed by the note number (13n1); those to the notes themselves are the page number followed by the chapter number and the note number (141c4n2).

A

access to museums 21–2, 29, 49, 51–2, 55, 56–60, 127

activism 91–4, 136–8

advocacy 34–6, 42–4, 118–19

Alexander the Great 15–18, *15*

Almeida, Ashley 23–9

American museum model 62

Andersen, Sofie 54–5, 56–7, 58–9, 61–6

Anderson, Susan 125, 126, 130–1, 132, 137–9

anthropological gaze 109–11

Ashmolean Museum 5, *5*, 6–9, 10–11

audience expectation 9–10, 22–3, 24–5, 127

B

Bankes, William John 128–9, *129*

Beetlejuice (film) 103

Belfast Agreement 70–1

belonging 45, 63, 65, 93, 97, 128–9

biculturalism 39, 138

Billings, Angela 103–6

Birmingham Museum and Art Gallery *31*, 32–6

Birmingham Museums Trust (BMT) 37–8, 40, 41

Black Lives Matter movement 130

Black Museum movement 138–9

Blombos, South Africa 18

Bloody Sunday 78

boiserie *47*, 49–50, 52–3, 61–2

Bojanowska, Maria 23–30

British Museum 15–16, *15*, 18–20, 21–2, 23

Brown, Ford Madox, *The Last of England 31*, 32–6, 38, 41, 42

Bunn, Maryellis 123

Burn, Lucilla 17

Byrne, John 48n1

C

cabinet of curiosities model 19–21

Calouste Gulbenkian Foundation awards 124

carbon footprints 117, 118

care 35, 36–44, 130–1
Charles III, King of Spain 20
Chipangura, Njabulo 106,
 109–11, 112, 114–16, 118,
 119–20
chocolate bar (exhibit) 78
civic and national identity 37–40,
 43–4
civic care 35, 36–44, 130–1
classical sculpture 14–18, *15*, 26,
 27–8
climate justice 117, 118,
 135
colonial tourist trade 103
colonial violence 21, 105–6, 109,
 110–11, 112, 115, 119,
 126–7
colonialism 35, 39–40, 41–2, 79,
 107–8
colonization 39–40, 41–2, 109,
 115–16
community collaboration 38
community connections 73–7,
 99–100, 115–16, 125–7,
 134, 135–6
costume collections 92–3
COVID-19 pandemic 48, 51,
 54–5, 56, 58, 74–5, 105,
 107, 124, 134
Cowan, Sarah 55
critical friends 79
cross-dressing 92–3
Crowdy, Hannah 73–80
culture wars 37

D

decolonization 79–80, 105–6,
 109, 112, 126–7, 135
digital access 29, 48, 51–2, 55,
 56–63, 135, 138
digital content 50–1, 52–3, 54–6,
 56–65, 66–7
digital engagement 74–5

display solutions 78, 92
domestic narratives 47, 48–50,
 52–3, 61–2, *70*, 71–2, 80,
 81
donations 19, 20, 131

E

Egyptian remains 4, *5*, 6–9,
 11
emigration *31*, 32–6
emotion in museums 6–9, 11–12,
 28–9, 43–4, 62, 97, 103–6,
 107, 128–9
environmentalism 116–19,
 135
Exile installation 128–9, *129*

F

Farrer, Peter 92–3
Ferdinand II, Archduke of Austria
 20
First Nations communities 39,
 138
folklore 44–6
funding 21–2, 131, 135
future museums *133*, 134–5

G

Getsy, David J. 83n1
Good Friday Agreement 70–1
Goosebumps (book series) 103
governance 21–2
Greek sculptures 14–18, *15*, 26,
 27–8

H

Harry Potter merchandise 103
Heal, Sharon 124–7, 134–6
Hemsworth family, Belfast *70*,
 71–2, 80, *81*
home interiors 47, 49–50, 52–3,
 60, 61–2

Hôtel de Varengeville, Paris 47,
 49–50, 52–3
human remains 4, 5, 6–9, 11,
 43–4, 101–5, 114–16

I
identity crisis 25–6
institutional practices 132–3
interpretation 24, 27–8, 34–6,
 42–4, 74, 80, 83, 88,
 89–90, 106, 113, 126–7
intersectionality 68–9, 130–1

J
Janes, Robert R. 13

K
Keenan, Charlotte 86–7, 88,
 92–3, 96, 98, 100
Kingston Lacy 128–9, 129
Konigsburg, E.L. 141c4n2
Kunst- und Wunderkammer,
 Innsbruck 20
Kunstkamera, Saint Petersburg 20

L
labelling 21, 34–5, 88, 89–90,
 102, 113
language in museums 97, 110
Larson, Frances 101n1
LGBTQ+ see under queer
Logan, Karen 73–80
Louvre Abu Dhabi 122

M
Manchester Museum 106,
 110–11, 114–15, 117
McWilliams, Jane 80
Medici, Cosimo 20
Met Stories 50–1, 52–3, 55–6,
 61–2, 65, 66–7
The Met Unframed 50–1, 53,
 54–5, 60, 66–7

Metropolitan Museum of Art
 (The Met) 47, 49–51,
 52–6, 59, 60, 61–2, 65,
 66–7, 141c4n2
Middleton, Craig 37, 38–40,
 41–4, 45
migration 31, 32–6, 38–40
moffa, sophia 33–6
Morse, Nuala 32n1
mummified remains 4, 5, 6–9, 11,
 114–15
Museu de Arte de São Paulo
 (MASP) 52
museum, use of term 122–3
museum buildings 61–2, 78, 132,
 138
Museum of Homelessness (MoH)
 123–4, 133, 134
Museum of Ice Cream 122–3
The Museum of Us (television
 programme) 38
museum partnerships 27, 28, 29–30

N
national and civic identity 37–40,
 43–4
National Civil Rights Museum
 138–9
National Museum of Australia
 39–40
National Museums Liverpool
 (NML) 82, 84–6, 92–3
National Museums NI 69–72, 70,
 73–80, 81
National Trust 128–9, 129
Night at the Museum (film) 103
9/11 Memorial Museum 137–8
Northern Ireland conflict 69–72,
 70, 74, 75–80, 81

O
object, use of term 110
othering 26–7

P

paintings *31*, 32–6, 38, 41, 42, 60
Palmer, Angela, *Ashmolean
	Mummy Boy 3 5*, *5*, 7–9, 11
Peabody Museum 112–13
Peter the Great 20
philanthropy 19, 20, 131
Pitt Rivers Museum 101–5, *102*,
	106, 107–9, 112–13, 114,
	115, 117
plurality 68–9, 130–1
politicization 34–5, 89–91
pop culture 9, 16, 18
popcorn anecdote 49–50, 52–3,
	61–2, 141c4n2
power imbalances 11, 20–1, 25,
	27, 53, 61, 105, 138–9
Prado 20
Prince, Simon 68n1
private collectors 19, 20
privilege 2–3, 22, 51–2, 60–1,
	131
propaganda 15–18, *15*
public funding 135

Q

queer, use of term 83, 97
queer artworks *82*, 83, 84–6,
	128–9, *129*
queer belonging 45, 93, 97, 128–9
queer futurism 95, 96–9
queer identities 90–1, 92–4
queer tours 91–2
queering collections 83, 86, 87,
	94–100

R

removal of exhibits 101–6,
	107–9, 112–16
repatriation 43–4, 108–9,
	112–13, 114, 117
respect 79, 115, 137

restitution 43–4, 108–9, 112–13,
	114, 117
'retain and explain' policies 37
Rice, Jo 9–12
Rococo art 47, 49–50, 62
Roman sculptures 16, 27–8

S

Sandell, Richard 13, 125,
	127–30, 136–7
sculpture 14–18, *15*, 26, 27–8
Secret Museum exhibition 124
shrunken heads (Tsantsas) 101–5,
	108–9, 113, 114
Shuar people, Ecuador 102–3,
	108–9, 115, 117
signage 21, 34–5, 88, 89–90,
	102, 113
Sloane, Sir Hans 19
Smith, Matt 86–7, 89–91, 93, 94,
	95, 97, 98–9
	Happy Union 82, 84–6, 99
societal change 27–8, 65–6
Spivak, Gayatri 106, 141c7n4
statues 15–18, *15*, 26, 27–8
Stienne, Angela 6–7
storytelling 27–8, 49–50, 52–3,
	57, 59, 61–2, 68–9, 83,
	138–9, 141c4n2

T

television set (exhibit) 69, *70*,
	71–2, 80, *81*
touring exhibitions 27, 28
traumatic objects 137–8
the travellers' tree (arts
	organization) 33–4
the Troubles (Northern Ireland)
	69–72, *70*, 74, 75–80, *81*
trust 59, 68–9, 71, 73–81, 127,
	128, 130–1
Tsantsas 101–5, 108–9, 113, 114,
	115

U
Uffizi Gallery 20
unionization 138

V
Van Broekhoven, Laura 106–9,
 112–13, 117, 119
Victoria and Albert Museum
 (V&A) 91–2
visitor expectation 9–10, 22–3,
 24–5, 127
Vo, Dan 86–7, 88–9, 91–2, 94–5,
 97, 99–100
Vora, Manish 123

W
Wajid, Sara 37–8, 40, 44–5

Walker Art Gallery 82, 84–6, 92–3
Wambold, Sarah 54, 55–6, 57,
 59–60, 65, 66
wardrobe collections 92–3
Wilson, David M. 19
wood panelling (boiserie) 47,
 49–50, 61–2
Woolner, Thomas 32

X
Xavier, St Francis 28

Y
youth engagement 27–8, 29

Z
Zimbabwe 109–10, 117

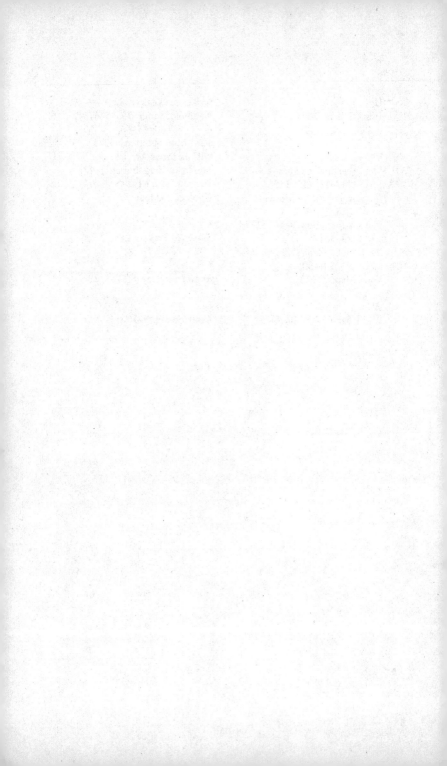